Pastels for the
Absolute Beginner

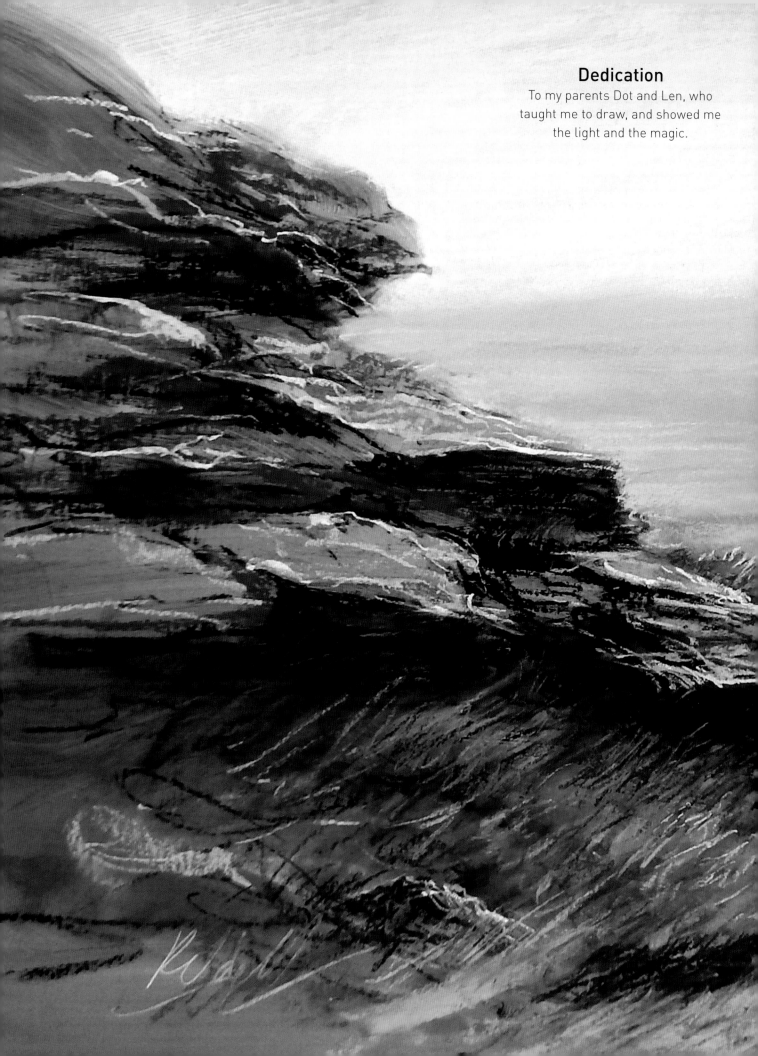

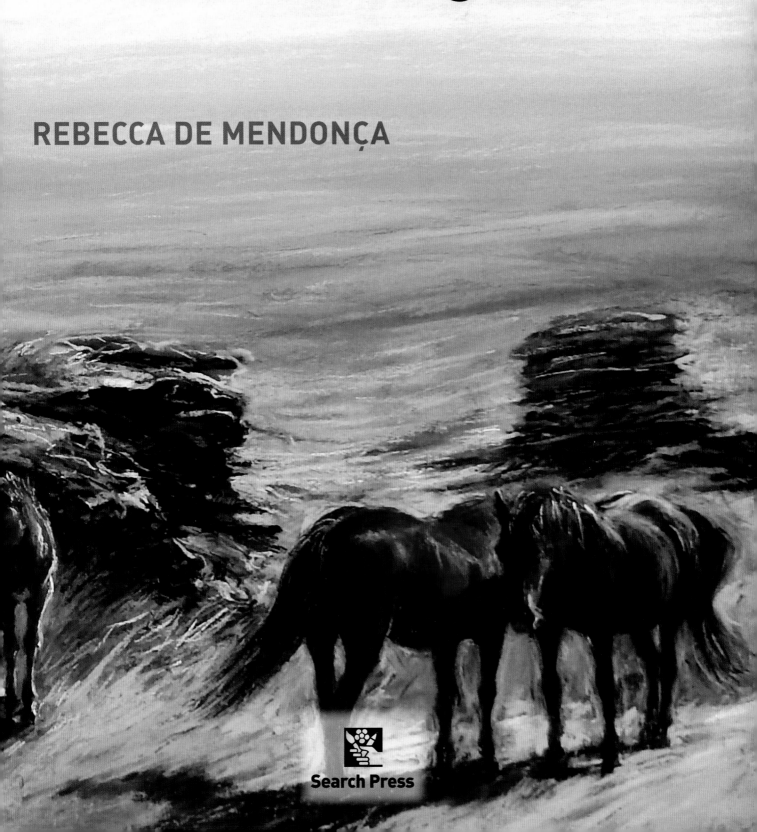

Pastels for the
Absolute Beginner

REBECCA DE MENDONÇA

Search Press

First published in Great Britain 2020

Search Press Limited
Wellwood, North Farm Road, Tunbridge Wells, Kent TN2 3DR

Illustrations and text copyright © Rebecca de Mendonça 2020

Photographs by Paul Bricknell at Search Press Studios, except for pages 42 (bottom), 110–111, and 139 (top) by Actual Colour; pages 67 (bottom), 127 (top) and 129 (left) by Colin Searle Photography; page 134 (bottom) by Formatrix; and page 141 (bottom), by Jeremy Vanes.

Photographs and design copyright © Search Press Ltd. 2020

ISBN: 978-1-78221-563-9

The Publishers and author can accept no responsibility for any consequences arising from the information, advice or instructions given in this publication.

Suppliers
If you have difficulty in obtaining any of the materials and equipment mentioned in this book, then please visit the Search Press website: www.searchpress.com

You are invited to visit the author's website:
www.rebeccademendonca.co.uk

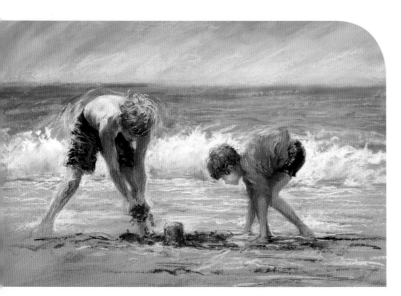

Acknowledgements

Heart-felt thanks to my family; to André for his strength, patience and for years of letting me be myself. To my wonderful, inspiring children, Manuela, Toby and Louis; as every day is a school day, this one's for you. To Dot and Len who started it all – and are much missed – and Jez for his wisdom and for introducing me to Conté crayons.

A big thank you to Nel, for years of support and collaboration, and without whom this book wouldn't have happened. To Colin Johnson for the cloud advice; Hannah Murphy for her equestrian knowledge; and to Ron Tiner for his book on figure drawing. For the use of their inspiring photographs, I would like to thank Nel Whatmore, Teresa Grant, Toby de Mendonça, Sarah Bradley and Dawn Westcott. Last but not least, to Edd the editor, who deserves a medal, and the great team at Search Press.

Left
Racing the Tide
This painting is all about the frenzied dash to save the sandcastle as the tide comes in. Both boys are bent right over, but even though they are moving, they are still balanced by the position of their feet in relation to their heads.

Page 1
Having Fun
This Arabian yearling is full of life and excitement. Here I went for the less-is-more approach by using a background surface that is very close to her colour, so that it is part of the palette. I focused on her lovely face and flared nostrils, while just hinting at her body with some light and shadow. I am relying on the viewer's brain to 'fill in the gaps' so that they get the sense of the yearling moving quickly, without all of the detail.

Pages 2–3
Dartmoor Ponies
I love the vast and dramatic landscape of Dartmoor, and like to give a sense of scale to this landscape by including life. Here, that life is in the form of the ponies who live wild on the moor. These landscapes are a great opportunity to experiment with mark-making techniques.

Opposite
Sitting on the Steps
This painting of Trafalgar Square in winter sunlight uses warm ochres to show the areas of light, and lilacs and blues for the shadows. There are greater tonal contrasts in the foreground to create a sense of depth.

Contents

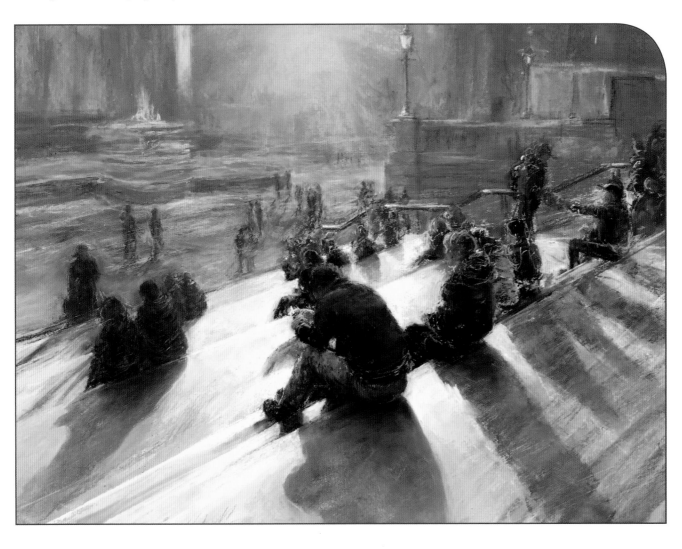

Introduction

Using soft pastels: is it drawing or painting? This is the question that I am always asked, and the aim of this book is to show you that the answer is both.

Depending on the way you use them, you can draw and paint with pastels, and produce work that ranges from detailed and delicate sketches to vibrant and expressive paintings. You hold the pigment in your hand, so can work immediately and directly, with no drying times to slow you down. You can combine several techniques in one piece, work in layers, and rub out or go over areas that you don't like. Pastels are versatile, forgiving and fun.

This book is for beginners to pastels, whether you are new to art in all its forms, or have experience with other painting media. Many people have dabbled a bit with a few cheap sticks, but would like to understand them and their potential in greater depth.

As people we are all different; and as developing artists we work in different ways, even with the same materials. That is one of the great things about art. It can sometimes be frustrating when you try something new, but hopefully some of the exercises in the book will feel easier and more natural than others. As the book progresses you will find ways of working that feel right, and if you keep practising, you will develop a style that is your own. Be brave and take risks.

I hope that you will enjoy this journey through the colourful and inspiring world of pastels, and get as much enjoyment from them as I do every day.

Trees on Red
This piece uses soft pastels on a red background. Red is complementary to the green of the leaves, and it is used here to create a feeling of dazzling sunlight. The vibrant contrast creates real impact.

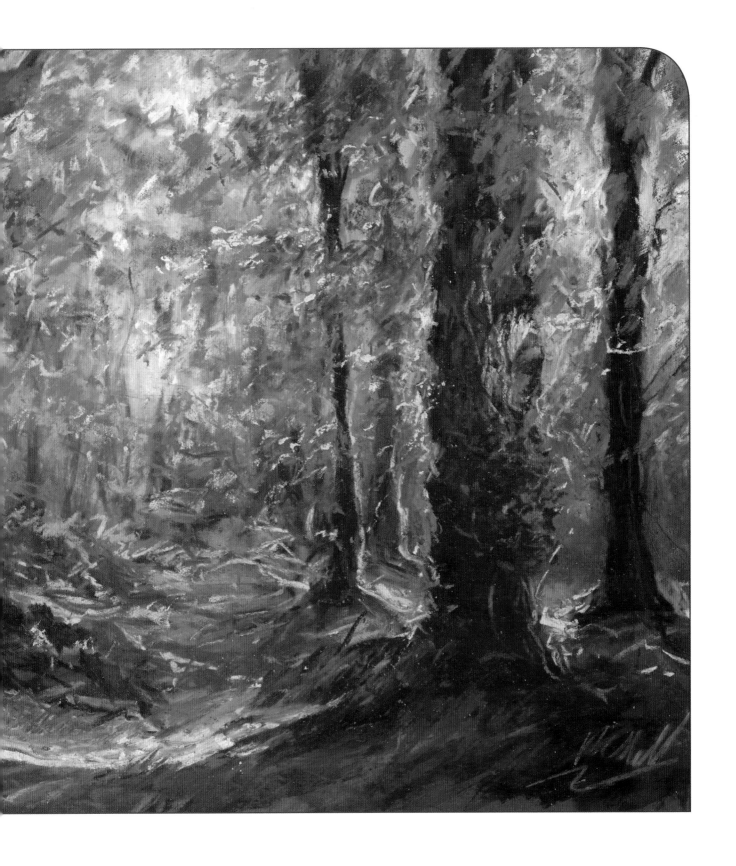

Materials

Let's get started. With everything that you do, remember that it is the experimenting that really matters. Try not to think about 'creating a masterpiece' or 'spoiling your work' by making changes. The worst that can happen is that it will go in the bin. My bin is always very full! We are all learning, and we only improve by practising, trying new things and taking risks.

■ What are pastels?

Artists' quality pastels are dry sticks of colour that you hold in your hand. They are called soft pastels, in order to distinguish them from oil pastels, which are an entirely separate medium. Soft pastels are a blend of two main constituents: pigment, which varies in quality, lightfastness and strength from brand to brand; and binder, which holds the pigment together in a form that can be held and manipulated. They are bought as sticks or smaller half sticks.

Despite the name, soft pastels vary from being soft to quite hard, depending on the proportion of pigment to binder, and the quality of pigment used. Artists like to have different grades of softness to work with, ranging from creamier pastels to firmer Conté crayons and pastel pencils.

Soft pastels Professional and artists' quality soft pastels are made with premium quality pigments mixed with a small amount of binder. This gives them a soft, almost creamy texture when applied. Much of the work in this book is done with Unison soft pastels, although many other brands would work for all of the projects. There are many other high-quality soft pastel brands, including Sennelier, Schmincke, Terry Ludwig and Jackson's.

Some soft pastels have more binder in the mix than really soft ones, making them feel firmer. I refer to them as 'medium-soft' pastels, to distinguish them from the really soft brands. I use Rembrandt, Winsor & Newton and SAA pastels as my artists' quality medium-soft pastels. They have a good range of colours, and many artists enjoy the sharp marks they can make with them.

Hard pastels Containing a higher proportion of binder to pigment in the mix, these pastels are harder and waxier than soft pastels, which makes them very useful for drawing and creating sharp edges. They also produce less dust. I use Conté Carrés sketching crayons – abbreviated to Conté crayons – as my preferred hard pastels. They are narrow sticks, square in section, and are made with a different type of binder to soft pastels and baked as part of the production process. They are much harder than my Unison pastels, but still artists' quality. Conté crayons are not to be confused with Conté pastels, or Conté pastel pencils.

Pastel pencils Encased in wood, like a graphite pencil, pastel pencils can be useful for very gentle sketches, subtle work and fine textures. In order for the colour to be strong enough to withstand sharpening, they have a high proportion of binder. I like to use Faber-Castell Pitt Pastel Pencils, as they are strong enough in terms of pigment to lay over soft, rich pastels. Conté pastel pencils are another good brand to use as they are hard but not scratchy.

Quality

Pastel ranges are available in students' and artists' quality. As a general rule, you get what you pay for with your materials. Students' quality pastels are cheaper than artists' quality, but tend to have a high proportion of binder in the mix and be made of lower-quality pigment, so will not be lightfast.

You will also find that with cheaper pastels you do not get a good range of very light and very dark tones, so your work may lack depth. I recommend using artists' quality pastels to start with if you can.

Lightfastness

A good quality artists' pastel will be lightfast, so will not fade in normal light conditions. With that said, no original artwork should be placed in direct sunlight. If hung away from sunlight, the colours of artists' quality pastels will last for years and years. Cheaper art materials may not be lightfast, and you run the risk of your work fading over time.

Starting out?

See page 14 for my suggestions for a closer look at the pastel colours I recommend.

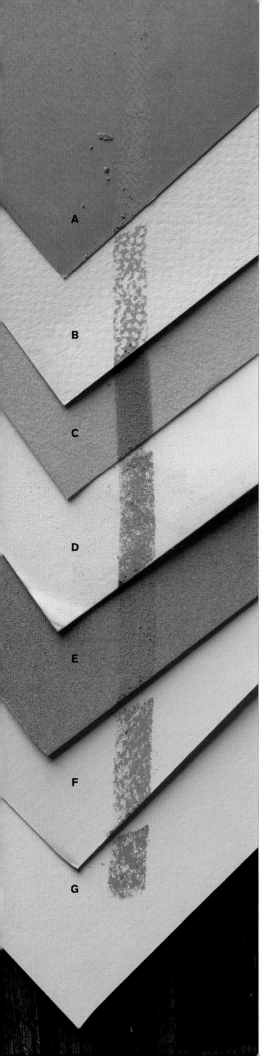

Papers and surfaces

Pastel paper

Pastel paper is the easiest surface to start with. Made for pastel work, it is strong and has a texture that can hold several layers of pastel. If you want your work to last, use an artists' quality acid-free paper. For the exercises and projects in this book, I use **Winsor Universal Paper** (A), and **Canson Mi-Tientes** (B). The latter is available in sixty colours ranging from whites, creams and subtle neutrals, to vibrant bright colours, darks and black. Like many pastel papers, both sides are textured, but one more than the other. Smooth papers can be tempting, but you won't be able to build up many layers of pastel, and a really smooth paper will result in the pastel skidding across the surface.

When you buy paper in pads, the more textured side is usually front side up. As this texture can be a little bit grid-like, it is a good idea to turn the pad over, and treat the back as if it is the front. This may seem a bit odd, but this grid-like texture does not always lend itself to natural subjects, especially people and animals. If you buy your paper by the sheet, you then have a choice of what size to work. It is easy to fold and tear in half if you want smaller pieces. It is usually good to go bigger with pastels as it is a loose medium, and working small makes life harder than it needs to be. I only buy paper in pads when I am travelling.

Other textured surfaces

When you have some experience working on paper, there are lots of textured surfaces to choose from, all suited to particular ways of working. Many experienced pastel artists make their own ground, using a combination of paints, primers, grit, pumice and other products.

Velour (C) This velvety surface is extremely good for soft and subtle animal work, but it can be difficult to erase marks.

Pastelmat (D) This surface appears quite smooth; but don't be fooled, it can hold many layers of pigment. It is excellent for detailed work, and people who draw and paint with confidence. However, it can be difficult to move pastel around the surface and to rub out from it.

Sand papers (E) Sand papers like Sennelier's sand card are very heavily textured. As a result, all the little bits of pigment sit in the tiny gaps and reflect in on each other, producing intensified colour. They are harsh if you rub in a lot with your fingers, and it is difficult to erase marks.

Primers (F) Colourfix primers produced by Art Spectrum are like ordinary acrylic primers but with grit or pumice added. You can buy pots of different colours to paint on yourself, or buy card ready-primed. This is a versatile textured surface that is fantastic for more experienced pastel users.

Canson touch (G) This lovely and versatile surface has more texture than a paper, is less harsh than sand papers, and comes in pads as well as sheets.

Tip

You can usually buy individual sheets of the textured surfaces listed, so try them out before you commit. We are all different, and some of them will appeal to you; others just won't feel right.

Other tools and equipment

Drawing board (A) Use a rigid surface to support your work. Drawing boards can be bought from art suppliers in several sizes, or you can have them cut to size from 6mm (¼in) MDF or hardboard at your local DIY supplier. A good size is 61 x 45cm (24 x 17¾in), which will hold a sheet of A2 paper – 59 x 42cm (23½ x 16½in). I have a selection of sizes, and also lightweight versions for working outside.

Masking tape or clips (B) These are used to secure your surface to your drawing board.

Scraper or flat metal blade (C) Used to remove excess pastel from the surface, you can make a scraper yourself from thin plastic or card. To prevent scratching your work with the scraper you make, be sure to use a craft knife and a metal ruler to cut the straight edge. A blade can be used in the same way, but you need to store it safely, and be careful when travelling.

Scalpel or sharp art knife (D) The perfect tool for sharpening pastel pencils, or cutting small bits of eraser. These are only effective when sharp, so be prepared to replace the blade regularly.

Dry kitchen paper or tissue (E) Use this for cleaning your pastels.

Wet wipes or a wet cloth (F) Keeping your hands clean will help to keep your pastels clean. Do not clean the pastels themselves with a wet cloth – it seals the outer surface, making them difficult to use.

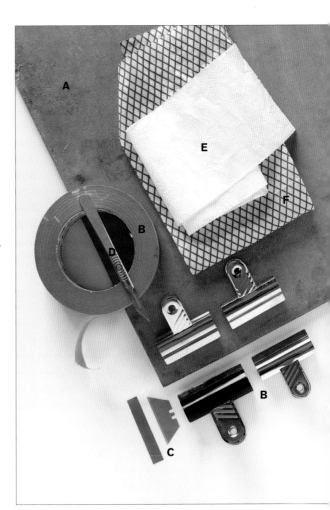

Optional extras

Fixative (A) Fixative can affect your colours and tonal balance. Because of this, many pastel artists do not fix their work. If you choose to do so, test the fixative first.

Mountcard, primer and household brush (B) Quick-drying acrylic primers that create a textured surface (or tooth) are available. Use a large household brush to paint the primers onto a smooth surface such as mountcard, then leave to dry. They are then ready to work over with pastels. You can use a single colour of primer, or mix them like paints.

Brush (C) A watercolour brush can be used to soften areas of pastel work. Some artists also use them to rub out areas that they want to work over.

Blender (D) A tool for blending small areas and sharpening details. Be warned that these can encourage you to focus on detail, and forget how enjoyable and effective it can be to work loosely.

Torchon (E) Made of tightly rolled paper, these tools can be used for blending small areas, although many people prefer to use their fingers.

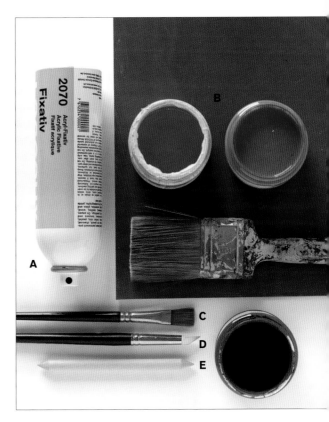

Setting up your workspace

You do not need a fully equipped studio to work with pastels. While pastels create a certain amount of dust, they do not smell, and don't dry out if you walk away and leave them in a pile. A table in a corner of a room would suffice, with an old rug underneath to catch the dust. It is a good idea to have a double layer of floor covering, which should be vacuumed regularly. If the top rug is small enough, it can be washed now and then.

Working upright at an easel

I strongly recommend that you have an easel, or a table easel if you are short of space. Working upright on an easel has two benefits. First, dust from the pastels will drop downwards rather than polluting your work; and secondly, working at an easel allows you to stand back to look at your work at regular intervals. This is essential, as pastels are a loose medium. Your work may look scruffy and unfinished when seen close-up, but totally different when seen from a few feet away. You need to stand back as often as you can and look at the 'bigger picture'.

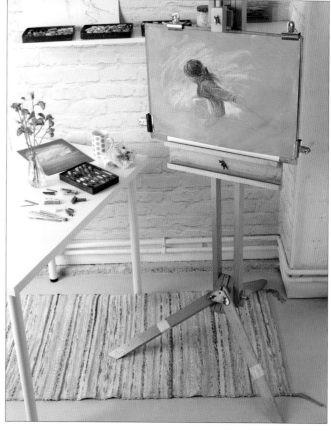

A simple set-up – note the rug beneath the canvas, and all equipment close to hand.

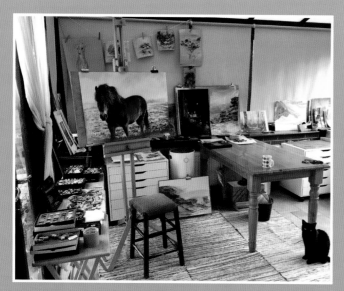

I set up my studio space to benefit from plenty of natural light.

This detail shows my studio pastel table. I keep a separate box of pastels for each work-in-progress painting, so that can keep all the pastel colours I need together and close to hand.

Display, protection and storage

Pastel work needs to be protected as it is a loose medium that can be damaged by a sweep of the hand, or an inquisitive pet. There are many spray fixatives available, but as these can sometimes alter the work, I prefer to cover my finished work with a clean piece of paper, or cellophane, which has the advantage that you can still see the work.

Framing

Due to their vulnerable surface, pastels need to be framed behind glass for display. The best way is to have a frame and a double mount to keep the pastel artwork away from the glass. A 'hidden mount' that sits between the mount and the artwork will provide a little channel so any excess dust will fall behind the main mount, out of view.

Before my pastels go in the frame, I cover them with a clean sheet of paper, and roll over them with a rolling pin, in order to push any loose pigment into the picture. I also tap them on the back to dislodge loose specks of dust. All of these little tricks minimize the likelihood that any dust will drop down onto the mount.

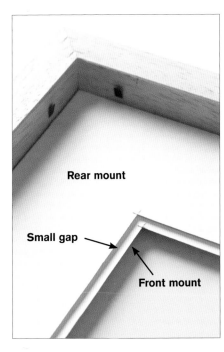

The double mount, seen here from the back before the painting is placed in the frame, acts as a channel to catch loose pigment.

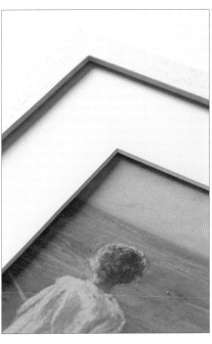

Once the painting has been placed in, only the front mount can be seen from the front, along with a subtle gap.

Storing your work

I stack my pieces in a plastic or cardboard folder or vertically in a storage box. Each piece of work is covered with a piece of paper or cellophane to protect it.

You could also store your work in drawers – I used to keep mine under the bed!

My storage area also contains files of reference photographs and sketches. My framed artworks are stored upright.

Getting started

This book is intended to make starting painting with pastels easy, so the pastels used throughout the book are referred to in general terms – 'dark brown' rather than 'brown earth 14', for example. However, if you would like to follow along exactly, each of the step-by-step demonstrations later in the book is accompanied by a list of the exact pastel colours I used.

Part of the enjoyment of pastels is making your own choices, so don't feel you need the specific colours listed. I encourage you to learn to trust your own eye – and if you do not have the precise colour that you need, then you can choose another that is similar in tone, or mix two together.

Pastels cannot be mixed in a palette like wet paints. We can mix them on the surface of the paper, using techniques such as blending and hatching (see pages 28–55 for information on techniques), as long as we have a good and varied selection of colours to choose from.

The techniques and step-by-step projects in this book will work with any brand of soft pastels, so feel free to experiment and find a set that works for you. My preference is for Unison soft pastels, which have what I consider to be the perfect blend of pigment and binder. The colours are rich and velvety, but the pastels are robust enough to be dropped on the floor without being destroyed. They are also lightfast, and handmade with natural pigments. If you choose another brand, look for these qualities.

The bare essentials

The list below contains everything a beginner needs for the techniques and projects in this book. It contains a selection of soft pastels, a few hard pastels (in the form of Conté crayons), charcoal and pastel pencils. As you gain experience and experiment with different types of subject matter, you can supplement this kit by buying individual pastels.

Unison soft pastels Your selection needs to include light, medium and dark versions of the main colours, as well as some bright, saturated primary colours, and a range of subtle, neutral shades. My suggested list of colours, developed by myself and Nel Whatmore at The New Pastel School after years of testing different colours, is as follows: grey 28, grey 27, blue green 6, blue green 3, additional 3, blue violet 9, blue green 7, dark 18, dark 8, green 15, green 10, yellow green earth 9, green 12, yellow 5, additional 9, additional 13, blue violet 6, blue violet 2, additional 31, grey 34, additional 42, grey 20, brown earth 14, orange 6, brown earth 6, additional 39, brown earth 29, red 10, red 7, additional 15. The 'additional' colours are usually contracted to 'add'.

Conté crayons A mixed set of twelve is ideal. The pictured sketching selection includes black, bistre and sanguine coloured pastels: 2437, 2450, 2451, 2452, 2453, 2454, 2459, 2456/B, 2460/HB, 2460/B, 2460/2B.

Pastel pencils You need only a few pastel pencils, but a range of tones is important. Pictured here are Faber-Castell's soft white 1121-101, Venetian red 1122-190 and burnt umber 1121-280, which provide a light, midtone and dark.

Willow charcoal Natural, burnt wood, charcoal is one of the simplest drawing tools. I break charcoal into pieces about 2.5–5cm (1–2in) long, and have thin, medium and large sticks; but almost anything will do.

Eraser Pastel work can be rubbed out, which makes it a forgiving medium to use. Pencil erasers work well, as they do not absorb dust in the way that putty erasers do. A pencil eraser can also be used as a drawing tool.

Tip

The soft pastels listed here are available as a starter set from my website:
www.rebeccademendonca.co.uk

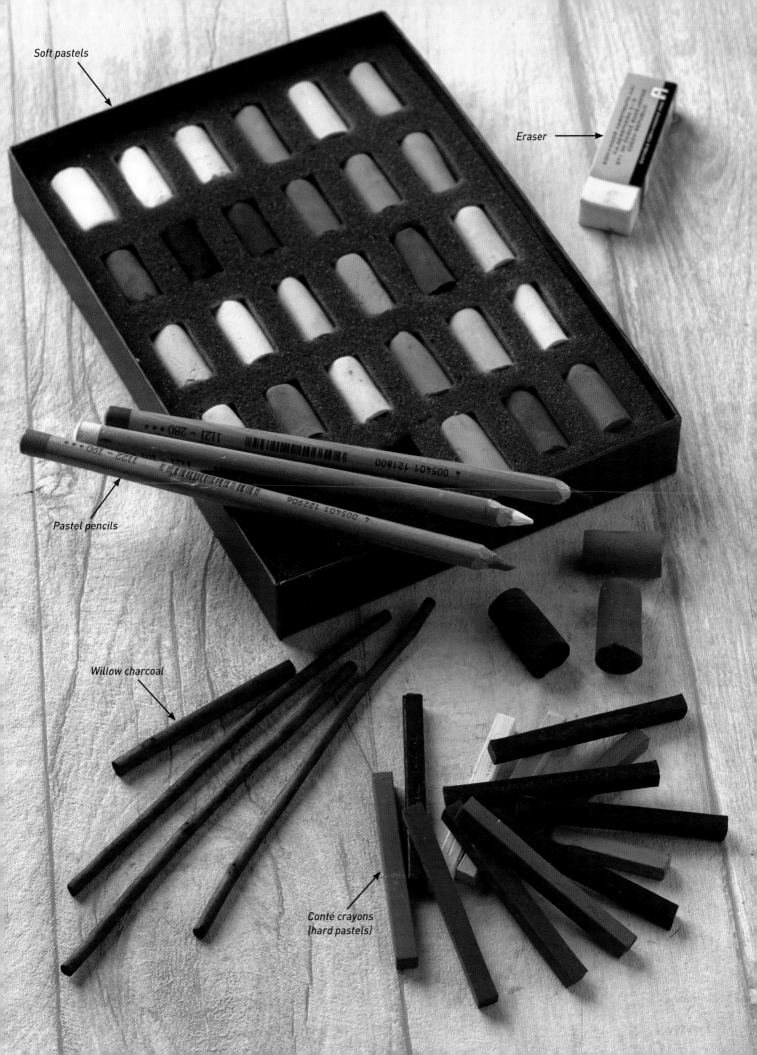

Soft pastels

Eraser

Pastel pencils

Willow charcoal

Conté crayons
(hard pastels)

Starting to draw

This is a brief introduction to drawing skills, using charcoal, Conté crayons and soft pastels. Drawing underpins a lot of pastel work. Even if you like to produce work that is loose and expressive, you may start to flounder without some basic drawing skills. Everyone can draw, and it is easy to learn how. Let's do some exercises to get us started. Regard it as limbering up!

Mark making with charcoal

With anything we want to draw or paint in a representational way, we have two main tasks. Firstly, how do we draw our subject so that it looks like it is real and three-dimensional? Secondly, how can we use our materials to achieve this?

We are going to start with a simple stick of willow charcoal. Charcoal is a great introduction to soft pastels. It is very 'forgiving', meaning that it rubs out very easily, so you can try things without any stress; whatever you don't like, you can remove.

I would suggest starting with a medium or thin stick, broken down to 2.5–5cm (1–2in) long. We are also going to use a simple pencil eraser.

Drawing with charcoal

Have a play with your charcoal on a large piece of paper, to see what sort of marks you can make. This can be cartridge paper, sugar paper, cheap practice paper: anything will do as long as it isn't smooth and shiny, as then the charcoal won't have enough 'key' (texture) to make a mark properly.

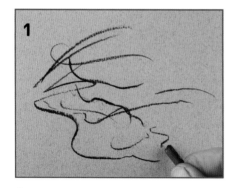

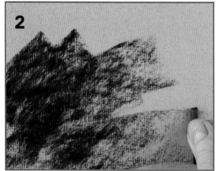

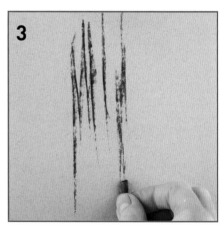

1 Working upright, secure your paper to the board using bulldog clips. Holding the charcoal like a pen or pencil, make a few lines and little marks.

2 You can use it on its side, by holding it in the middle of the stick, and making broad, sideways strokes.

3 You can hold it in the middle, and drag it up and down to make linear marks.

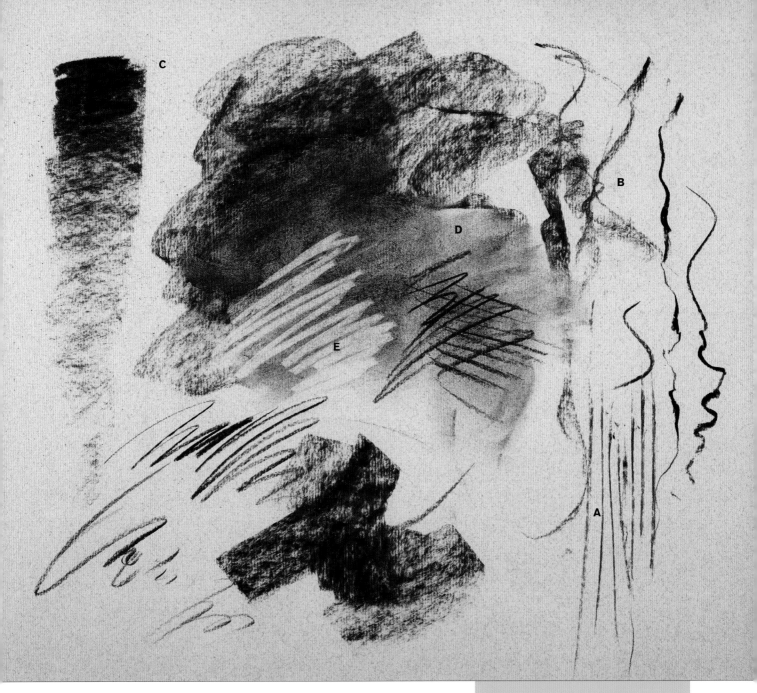

Ways to experiment with willow charcoal

- Try out the different marks you can make using the end and the side of the stick.

- Change the way you hold the charcoal.

- Try sticks of different sizes; you can buy mixed packs.

- Change the pressure you apply: let it just graze the surface, then press really hard so that it powders on the paper.

- Smudge it: see how easily it comes off the surface.

- Rub it out with a pencil eraser.

- Get messy, experiment, have some fun.

Mark making

This shows a variety of marks:

A: Linear marks using the end of the charcoal stick.

B: Linear marks using the edge of the charcoal.

C: Broad marks using charcoal on its side.

D: Smudged marks.

E: Rubbed out with a pencil eraser.

Drawing made simple

Drawing doesn't have to be complicated. We don't have to copy our subject exactly, we just need to give the viewer some clues to describe we are drawing. If we give them the right clues, their brain will fill in the rest of the information. However complex the subject matter, you can usually follow a few simple steps to capture an impression of it.

Looking carefully is essential, and something you may not be used to doing. Take a good hard look at what you are going to draw, an apple in this case, and ask yourself some questions:

- How wide it is in relation to its height?

- What sort of shape is it?

- Is it textured or smooth?

- Where is the light coming from?

- What do you like about it?

- What do you want tell the viewer about it?

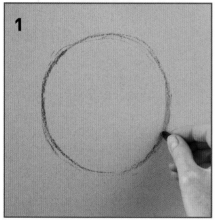

You will need:

Willow charcoal

White pastel

Winsor paper: Midtone mottled grey

Eraser

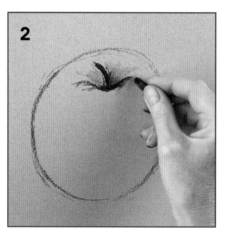

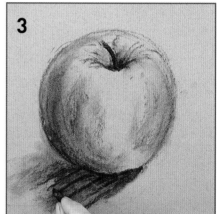

1 To place the apple on the paper, and decide on its size, we can simplify it, and draw a circle.

2 What really makes it look like an apple is the dip in the top with the stalk coming out of it. With charcoal, I can have a few tries to get it right. It is easy to make changes to the initial shapes at this early stage.

3 The way the light falls on an object tells us about its structure, as the shadows describe the form. Notice the shadow it is casting onto the table. Use the charcoal lightly on its side and soften it in with your finger. Drawing shadows makes our drawing look three-dimensional.

Tip

It will make drawing much easier if you have strong light from one direction, such as natural light through a window, or an electric light at one side.

It can be a great help to sketch an arrow in the corner of your paper showing where the light is coming from.

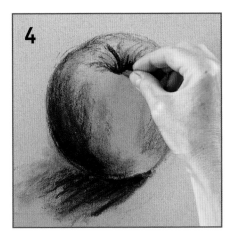

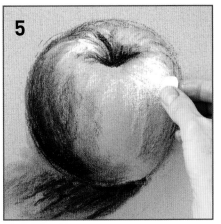

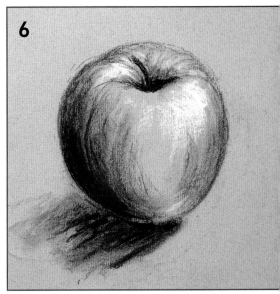

4 To describe your apple even more, press harder to get darker shadows.

5 Use a white pastel to create glow and shine. By making your marks follow the contours of the apple, and curve around it, you will describe the markings on its skin.

6 Refine the highlights. Look carefully at the way that they disappear into the indentation that holds the stalk.

Turning two dimensions into three

Many objects can be simplified down to a basic two-dimensional geometric shape and more complicated subjects are often a combination of these simple shapes. All you need to create the illusion of three dimensions are shadows. A circle becomes a sphere, a triangle becomes a cone, and a rectangle could become a cuboid or a cylinder.

The trick to this is to look at what you want to draw and try to think of the simplest shape it would fit into. You can practise by drawing fruit, vases, mugs, or anything that you have to hand at home.

Looking more carefully

A great way to train your eye to see more carefully is to have a few objects that are quite similar when simplified, but that you know are different. For example, the apple, satsuma and lemon below are all essentially circular or oval in shape. You therefore have to look more discerningly for similarities and differences. The fruits here are different in:

- Size: The apple is larger than the lemon and satsuma.

- Proportion: which means their height in relation to their width. The apple is taller than it is wide, but both the lemon and satsuma are short and wide.

- Shape and form: Although they all started as circles or ovals, they are very different.

- Texture: The apple is shiny and smooth, but the other fruits are shiny and pitted.

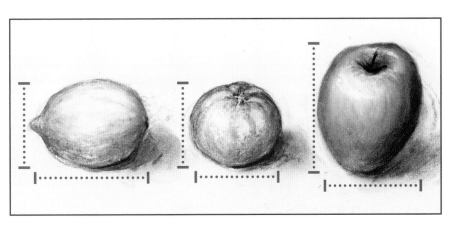

Understanding tone to develop your drawing

Grades of pastel and tonal ladders

Tone simply refers to how light or dark something is. We are now going to carry on working in black and white, but we are expanding our tool kit of materials considerably. This is because there are different grades of pastel and charcoal, and by getting to know how they behave, you can add depth to your drawings.

Whatever medium you are using, it can be a great starting point to make a tonal ladder, as shown to the right, to establish what the lightest and darkest tones you can create are. Using our tonal ladders, we can also compare how using willow charcoal, Conté crayon and a soft pastel can give different qualities of lights and darks. These are all very tactile media, so it is not just about what they look like, but also about what they feel like as you apply them. Good-quality pastels, for example, have a richness of pigment that is denser and more creamy than charcoal. This can help to soften your work.

Making tonal ladders

At the ends of the ladders, black pastel has been used for a stronger dark, and white pastel for a brighter, richer light. In between, charcoal and white Conté crayon have been used for the gentler darks and lights respectively.

The ladder on the left uses the paper as the midtone, while the ladder on the right is smudged to blend the colours, so the paper doesn't show through as much. Notice how when you smudge the black and white together to blend them, you get a different quality of grey.

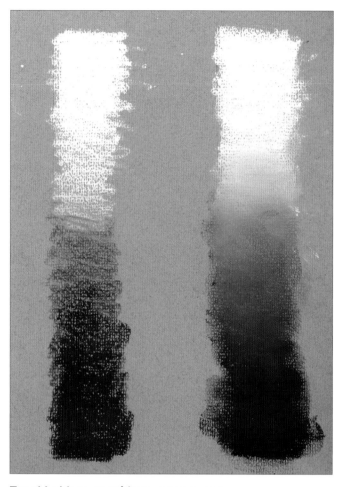

Tonal ladders on midtone grey paper
The colour and tone of your paper or surface will be part of your palette, as you can leave it to show through your drawing in places. So the tone of our paper is part of the tonal ladders, particularly on the left.

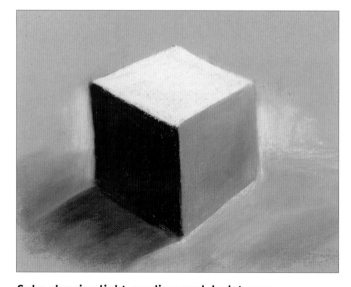

Cube showing light, medium and dark tones
A simple cube is a great way to practise your use of light, medium and dark. This one is drawn with a black, grey and white soft pastel.

Tones and outlines

Nothing has an outline. Outlines help us get the shape and size of our subjects on the paper, but we don't see outlines when we actually look at objects; what we see are forms against other forms. Some are darker and some are lighter than what is around them.

It is the difference in tone of objects against each other that is interesting. This is how we can make a group of objects, like the boots here, look real.

Practise your drawing by using everyday objects. Start with things that aren't too colourful, so that you concentrate on tone.

Tip
Screw your eyes together and squint at your subject. This helps to exaggerate the tonal differences.

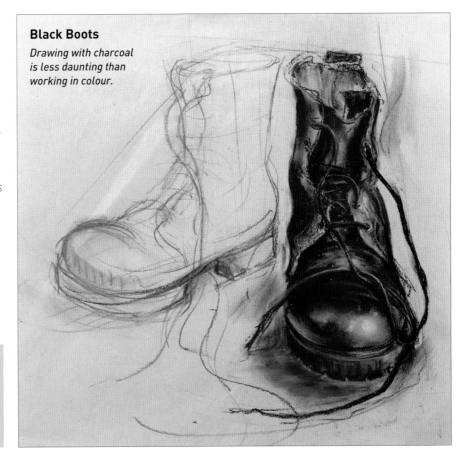

Black Boots
Drawing with charcoal is less daunting than working in colour.

How relative tones behave

First let's look at how tones behave when placed against each other, and how our eyes can be tricked.

Look really carefully at the tones in the pictures to the right. Notice how different the tone of the charcoal square looks in each case – in fact, it is the same in both examples.

The square of charcoal can be made to look darker or lighter by what is around it, or against it. This is something we can use to our great advantage when we are drawing.

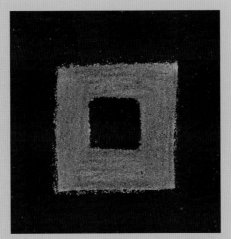

Relative tone 1
This charcoal square has a black pastel square within it, and black pastel around it.

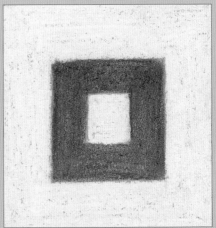

Relative tone 2
This charcoal square has a white pastel square within it and white pastel around it.

The White Jug

Now let's look at how we can draw lights and darks against each other, and lose those outlines. We are going to draw the form of the objects through our use of light and dark. We are going to change the tone around the objects to make them look more real and three-dimensional.

In this still life, we are going to focus in detail on some areas, and just hint at the rest of it. The main focus is the white jug against a darker background.

You will need:

Winsor paper: Midtone mottled grey

Willow charcoal

White pastel

Eraser

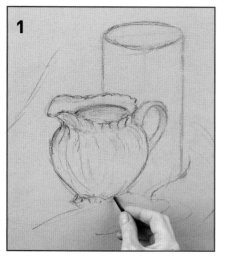

1 Start by using the charcoal to draw outlines of the jug and vase, to help get the shape and size of the objects on the paper.

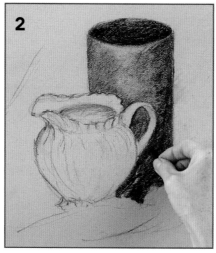

2 Fill in the dark areas using the side and tip of the charcoal. The objects start to look three-dimensional, with the white jug in front of the dark vase.

3 Start to add medium tone on the cloth. Suggest shapes by twisting the charcoal.

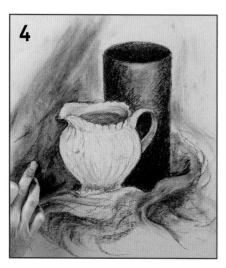

4 Establish the relative lights and darks with charcoal. Notice how I have changed the tone of the background around the objects, to emphasize light or dark tones.

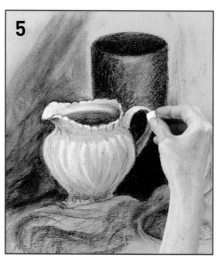

5 Having established the relative lights and darks, develop the highlights with white pastel.

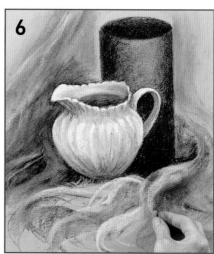

6 Continue to build up the tones across the drawing, adding white pastel to the cloth.

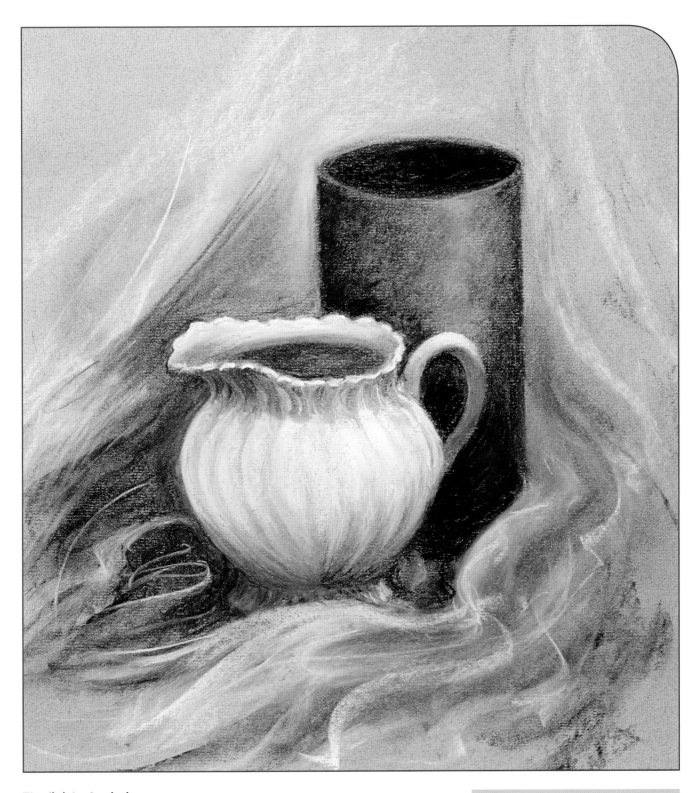

The finished painting

Notice how I have changed the tone of the background around the objects, to emphasize light or dark tones, and to manipulate the viewer's eye to see what I want them to see.

The curved marks made with the white pastel help to show the shape of the jug and hint at the folds of the cloth.

Tip

Artists often use the phrase 'less is more', and this definitely applies to pastel work. We do not have to draw everything that we see, and often, the more we leave out, the better our drawing will be.

Character and decoration

Being able to work lights over darks is one of the great joys of working with pastels, as it gives us the chance to change our drawing as we go along. It also makes depicting pattern, decoration and shine good fun. In the still life shown here, I chose to draw black and white objects, so that I could still concentrate on tone, without getting confused by colour.

As with *The White Jug*, I drew a rough sketch of outlines to place the objects on the paper, starting with simplified shapes, and just using charcoal. I used charcoal to create darker tones, and to put shadows in to create form. I used white pastel to establish areas of light.

Next, I started to use black pastel to deepen the shadows, creating more depth and drama, and I pressed harder with the white pastel to brighten the lights where the light was hitting the lighter objects. I only started to draw the pattern and decoration when I was happy with the form of my objects. I can use the white Conté crayon and pastel over the darks, and by gradually pressing harder with the white soft pastel, I can create the quality of the metallic shine. The decoration follows the contours of the round objects.

The last touches are done with hard flicks of the white soft pastel to create shine and sparkle.

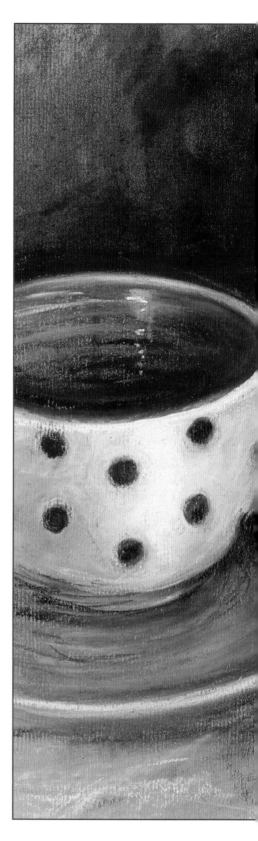

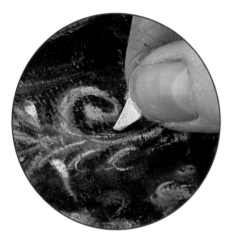

This detail shows how I used the white pastel to draw pattern and decoration over a dark area on the little vase. For more practice with shine and sparkle, see the bauble on pages 36–37.

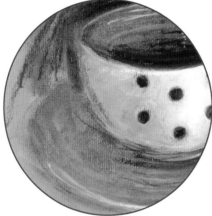

My initial drawing was rapid and quite loose, and then I tightened up areas where I needed to. I drew the whole cup and saucer, even though I intended to crop off part of it when the piece was finished (see right). This helped me to ensure that the ellipses were accurate.

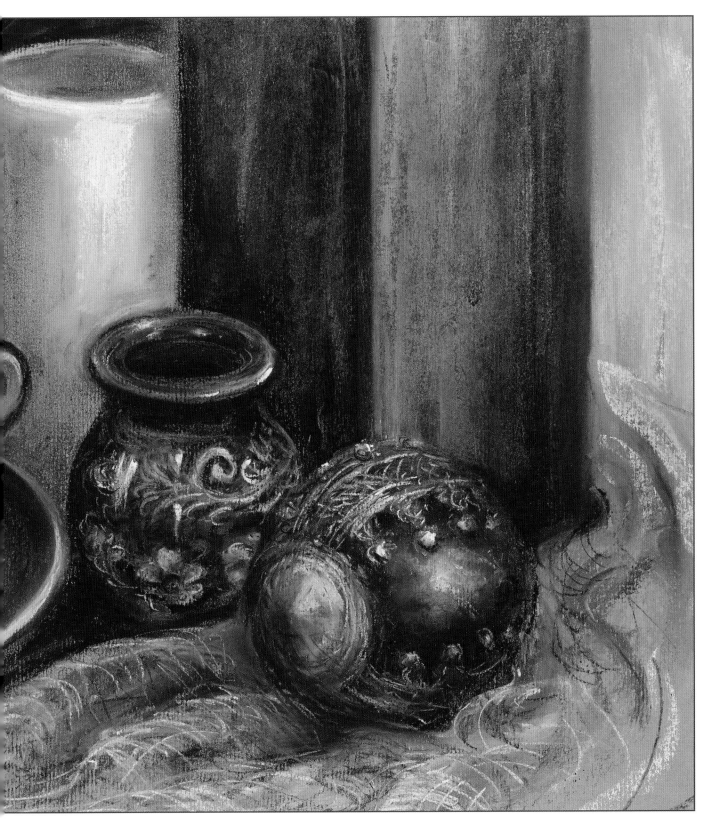

Decorated Still Life

Note that the decoration follows the contours of the round objects. This still life work was drawn looking at the objects in front of me, rather than a photograph. Working this way ensures you have more information in front of you. It will help to improve your drawing skills because it encourages you to look and draw more carefully.

Tones and colour

When you start to use colour, everything can suddenly seem rather complicated – and it is! However, remember that the tonal variation (i.e. how light or dark something is) still matters just as much as when you are drawing with black and white. This can help to guide you.

For this painting, *Aladdin's Lamp*, I worked in a similar way to my black and white drawings. I still used light, medium and dark versions of colours, and I also started with darker colours, and put lighter ones over the top. Even the metallic shine is produced by using lights against darks.

This detail shows how different tones of browns, yellow ochres and creams are used to create a metallic shine. As before, the darks were put on first, and then lighter colours added gradually.

We will look in more depth at how to use colour later in the book, and how to create shine and sparkle with colour pastels on pages 36–37.

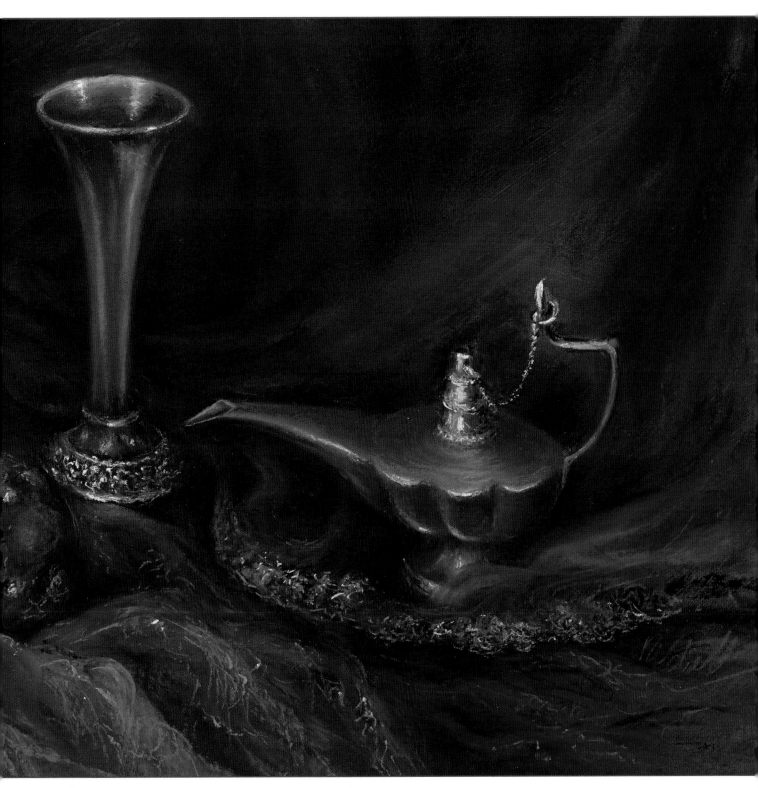

Aladdin's Lamp

Pastel techniques

One of the main aims of this book is to help you to find your style. There is a rich variety of techniques to try out and get a feel for, and as you gradually try them, you will find that some are enjoyable, whereas others can seem more difficult to grasp. The important thing is to find which pastel techniques work for you, and feel right. We are all different, and even within this medium, you can find a way to express yourself that is true to you. Just look at the work of a selection of pastel artists to see how many ways there are to apply pastels.

Because pastels are rich in pigment, we can build up layers of colours applied in different ways, which can lead to exciting, lively work. Because you often need quite a

few layers of pastel to achieve a smooth finish, it helps to use a paper or surface designed for pastel work. Unlike cheaper, smoother surfaces, this will have enough texture to hold several applications of pigment.

In this section we explore some examples of different techniques, marks and examples of their application in more depth. To start with, we can experiment with some of the mark-making techniques we used with charcoal. These can be developed further with pastels.

Using a pastel: broad strokes

For this technique you use the pastel on its side. I usually take the labels off my pastels and break them in half.

1 Holding the pastel in the centre, draw the side across the paper to make one bold stroke. Feel how soft it feels in comparison with charcoal, and see how rich the pigment is.

2 Experiment with different pressures, and you will discover the range of marks that you can make.

3 When you stroke one colour over another, the colours will merge slightly. Leave the marks – don't be tempted to try to blend them together. Instead look at the variety of colours in the marks as they naturally blend together slightly.

4 Continue layering, trying not to smudge the colours together, as smudging will result in the integrity of each colour being lost.

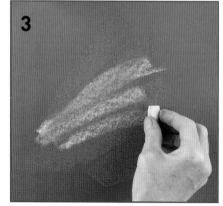
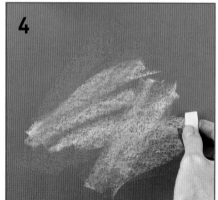

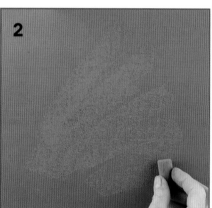

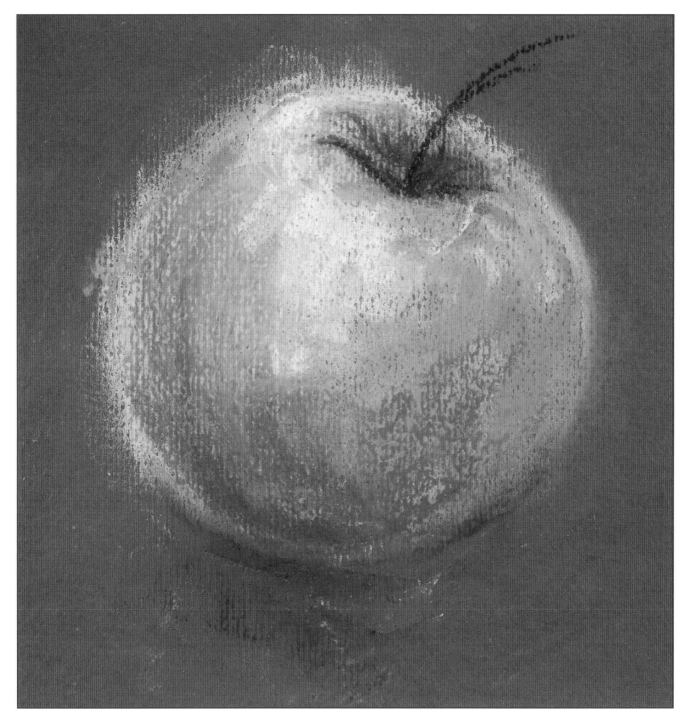

Apple drawn using broad strokes of colour

When I drew this quick colour sketch of an apple, I still had to think about lights and darks, just as we did with the charcoal tonal sketch of an apple on page 19. Even though I used yellows, greens and reds here, rather than black and white, I still had to consider where the light was coming from. Darker tone was used to suggest shadows – I pressed harder with the green under the apple, and used a blue to create the dark cast shadow. It is good fun and great practice to do quick sketches like this.

Using the broad strokes technique

To get the feeling of a windswept day, we can make our marks with energetic strokes. When you use this technique, detail is only important on the focal point of your painting. Most of this piece was painted using the pastel on its side. The broad strokes were left untouched in the final piece, apart from in the distance, where they are smudged by hand.

It is always difficult to know when to stop when working in a broad, loose style like this. The best thing to do is to stop before you think you have finished, and walk away, only coming back to look at it several hours later.

This detail shows how I have dragged the pastel over the textured surface, and left it without smudging. This gives the piece some energy, and contrasts with the misty focal point further back. I like the way the colour of the surface shows through, and it hints at shadows where the land isn't flat, or the earth is showing between the grasses. Remember the phrase 'less is more'. Using a few broad marks creates the suggestion of texture, rather than drawing everything in great detail.

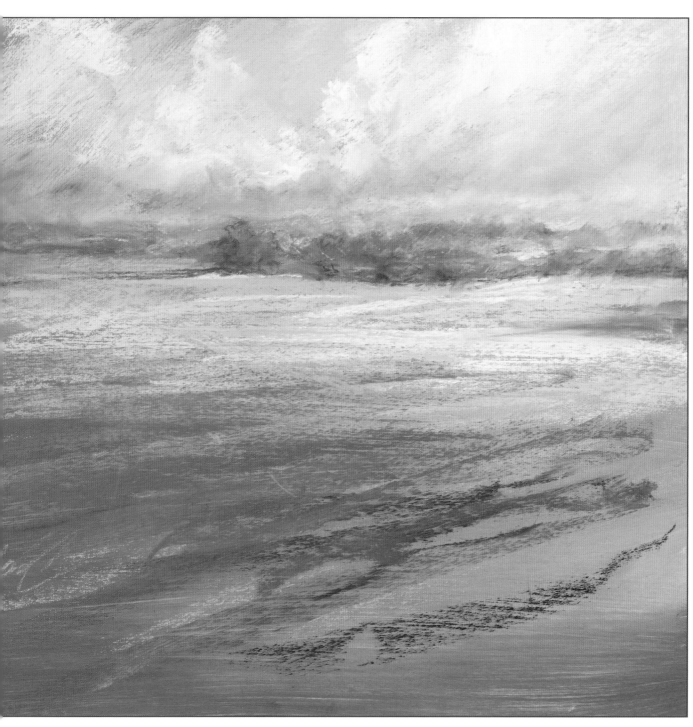

Open Fields

Tip

Step away and stand back. When working loosely, you should stand back as often as you can, ideally every few minutes.

▊ Smudging

Smudging with your fingers or tools is a useful and popular pastel technique. It is also called blending. The best smudging tools are your fingers, and for large areas you can use the side of your hand. This will prevent the ends of your fingers from getting worn away on textured surfaces.

There can be a temptation to smudge more often than you need to, sometimes due to lack of confidence in the marks you have made. It is therefore always a good idea to ask yourself why you are smudging. Some very good uses for the techniques are:

- To provide a soft ground to work over if you want to build up layers of interest

- To create a feeling of smooth textures, such as skin, hair or fur

- To have a gradual blend of colours, such as for skies

- To diffuse the intensity of the colours that you have used, by flattening them or mixing them all together, which artists refer to as 'knocking back'. This works really well for pastel landscape painting.

Even just one pastel colour applied directly and left as it is will appear bright and lively against the colour of the surface. When softened and blended, it becomes physically flatter as well as smoother, and the vibrancy is lost. This is why you have to be sure that by smudging you are creating an effect that you want.

Tip

The best types of pastels to use for smudging are good quality soft ones, as they have a creamy texture that can give a lovely soft blend.

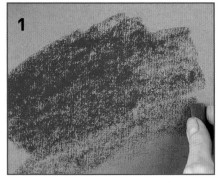
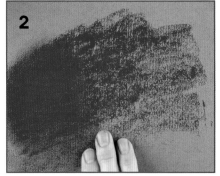
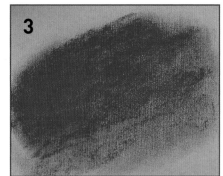

1 Lay in a few bold overlaying strokes as described on page 28. It's important that there is enough pigment to smudge; just one layer of pastel will not be enough to cover the colour of the paper when smudged.

2 Use clean fingers to rub over the top, smudging the colour into the surface.

3 The pigment will merge together, creating a smoother and flatter effect that covers the surface. Note that the effect is not as smooth towards the edges of the area – this is simply because there is not enough pastel pigment at the edges to fill in the texture of the paper.

Tip

If you apply several layers of very soft pastel, the rich pigments can clog the surface. To refresh your surface so that you can carry on working without all the colours merging together, scrape a stiff piece of plastic over the surface. Make sure the plastic has a straight edge, or it may scratch your work.

Smudging two colours together

Smudging can also be used to merge or blend two colours together, creating a smooth transition.

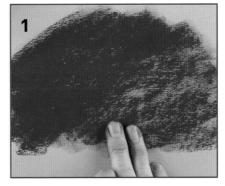

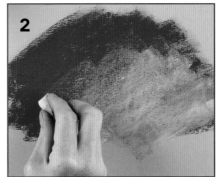

1 Lay in a few bold strokes of your first pastel, and smudge it lightly into the surface.

2 Pick up your second colour and overlay some of the smudged area.

3 Smudge the colour in just as before; note how the colours blend into one another.

4 If the colour isn't what you want, you can strengthen one or other of the colours with another layer.

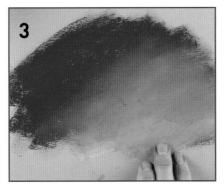

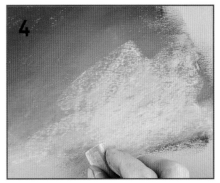

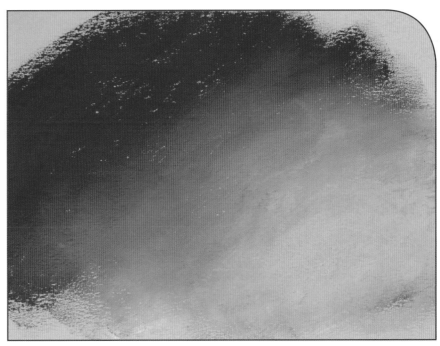

The finished effect

Tip

You will need to clean your pastels as you apply layers. I use a soft dry cloth or a tissue to wipe them clean. It must be dry, as making pastels wet creates a sealed surface, which means that they won't work properly.

■ Using the smudging technique

This painting of a soft, fluffy cat was built up in several layers. To create the impression of very soft fur, it is important use quite a few layers of pastel, but it is also important to show contrasts to the soft areas with some sharper, more defined marks.

I used lilac greys and cream soft pastels for the white fur and darker brown soft pastels for the face, with flicks of sharper charcoal and Conté crayons to create whiskers and finer hairs. The contrast of these darker and sharper marks on the face helps to make the smudged white fur look even softer.

The dark areas under the soft white fur were sketched in first with a small amount of charcoal to have a structure to work over. Then a soft lilac grey Unison pastel was used to smudge in the next layer. Smudging in a background colour gives a soft, cushioned surface to smudge the lighter fur over. It can be difficult to create softness against the surface of the paper, so you need to apply more layers.

Then I smudged a soft cream pastel over that, and areas of thick fur were added by pressing hard to fill in the texture of the surface, and softening with my fingers.

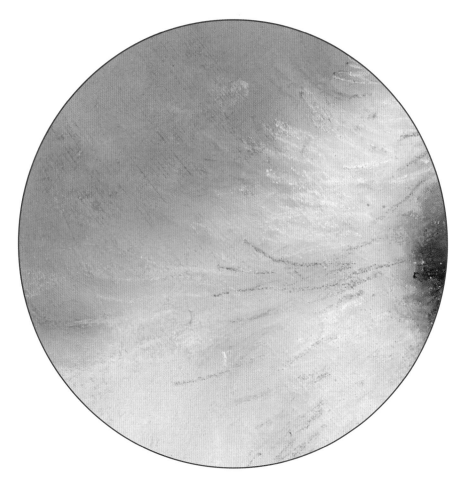

By smudging in the blue background, I had another soft layer to work over for the smudged cream fluffy edges.

Jub Jub

Bauble

One of the great advantages of using soft pastels is that you can put lights over darks. It is a forgiving medium and you can easily make changes, so you can work in a relaxed way, taking risks and trying out whether things look right or not. If you don't like it, you can just smudge it out and work over it.

To create drama we use strong lights and darks to capture the effects of shine and sparkle. We start with the darker tones, and then gradually build up the light ones in layers. Don't worry if you do not have the exact colours listed, what is important is how light or dark your colours are. I used Unison dark 6, add 29, dark 5, brown earth 29, grey 20, brown earth 7 and yellow 15.

You will need:

Pastel paper: Any dark colour
Pastels: Dark brown, dark purple, very dark brown, mid brown, yellow ochre, cream and golden yellow
Scraper

1 Start by sketching out the circle of the bauble using dark brown. Use a light touch.

2 Use the same dark brown to begin adding the background, using loose relaxed strokes that indicate the folds of the fabric. Change to dark purple to develop it a little more.

3 Switching between the same two pastels, add some shadow to the lower left-hand side of the bauble. Smudge the shadow in to suggest the rounded shape and to make the bauble look more three-dimensional.

4 Use the very dark brown pastel to add the deep shadows, smudging it in as you go. When smudging, try to further emphasize the form.

5 Add mid-brown to the bauble, smudging it into the black on the surface.

6 Add ochre to further suggest the roundness, concentrating on the top right area. Smudge it in, then add a small curved stroke on the lower-left, as a reflected highlight.

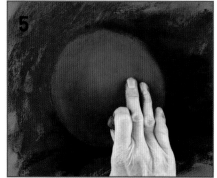

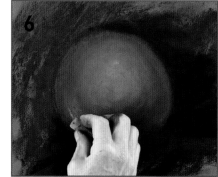

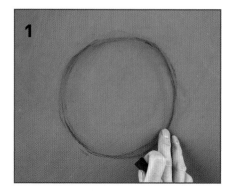

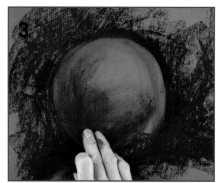

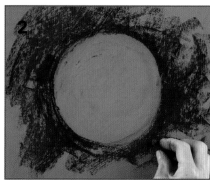

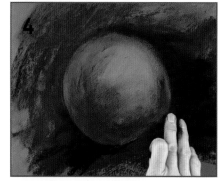

7 Use two or three layers of cream pastel to add a highlight as shown, smudging in the colour between each layer. Don't worry about having a sharp edge to the bauble – because you can work light over dark, you can refine it later.

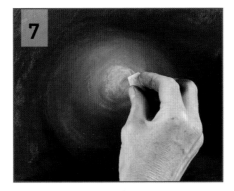 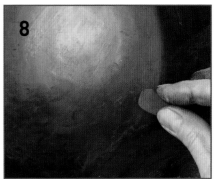

8 Using the mid brown pastel, lightly dot in a little reflected colour around the sides. The marks this makes will suggest texture.

9 If any marks stand out too much, or you want to soften them without destroying the surrounding area, tap them gently with your fingers.

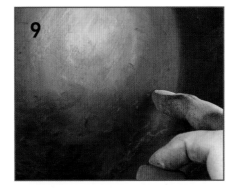 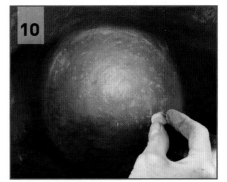

10 Repeat the process with the golden yellow pastel to pick up the shine on the bauble.

11 Use the scraper with a twisting motion to refresh the bauble's surface (see page 32).

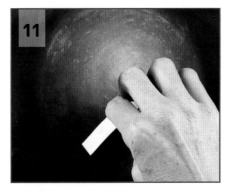 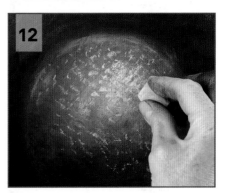

12 When adding the final highlights, use your lightest colour – in this case, cream. Press hardest where you want the brightest marks.

The finished painting

You cannot create shine and sparkle without having strong darks to set them against. It is this contrast that will make your drawing effective and exciting. Note that I did not smudge in my final cream highlights. By getting those little 'crunches' of pastel on the surface and refraining from smudging them, you give them greater intensity, which creates even more sparkle.

Tip

Christmas baubles make great subjects for this technique. It always helps when creating a piece like this to set the shiny object against a dark background, and to shine a light on it. Look at it carefully and see where the light hits it, and where the shadows are.

Hatching and cross-hatching

'Hatching' is a term artists use when they are making repeated marks or lines that tend to go in the same direction and are parallel. Here we are going to hatch in a much more free way, by varying the space between our lines, which don't have to be parallel.

Hatching is a fantastic way to mix colours, as by hatching several colours together and refraining from smudging them, we let our eyes blend them optically. If we smudge, we lose the beauty of each colour reacting with the others that surround it. This technique works well with hard pastels, as they give you more control than soft pastels.

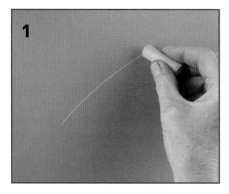

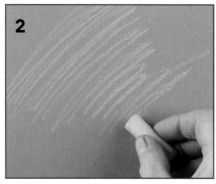

1 Holding a hard pastel a little like a pencil, draw a line.

2 Make some other lines that follow the same direction – this is hatching.

3 If you overlay with lines running in the opposite direction (I'm using blue here for clarity), it builds up strength of tone and is called cross-hatching.

The finished effect

Pastels allow you to continue building up with multiple layers. You can hatch colours alongside each other, or build up layers to create more subtle mixes. Play around with the simple technique to see what lovely colour blends you can create.

Hatching for form

As well as combining colours with hatching, we can use the technique to describe form. It is also a lovely way to get detail, control and refinement into your pastel work.

We can adapt our use of hatching to suit the subject matter, the scale of the work and the type of pastels that are used. It can be left bold and striking, or smudged softly so that the viewer can hardly see the way the marks have been applied.

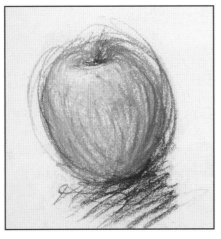

A simple apple painted using hatching. You can let your hatching marks curve, to follow the contours of the form.

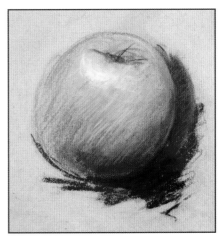

This apple has a smudged underlayer; the overlaid hatching helps to tighten and sharpen the shape.

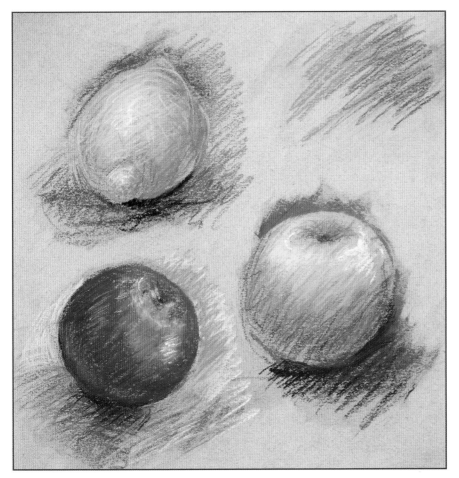

Hatched fruit

Pieces of colourful fruit make good subjects for practising this technique. When fruit is fresh, it reflects what is around it, both colours and light. Notice how many colours have been introduced in these sketches. We will go into colour mixing later in the book, but this technique allows you to experiment with adding small flashes of colours to add life to your work.

Some of the marks on the lemon curve to follow the contours of the form. There are no rules with this; your marks can go in any direction you like. By using curved marks to follow the form, you can use a few marks to give the viewer important information about the form of objects that you are drawing and painting.

Tip

It is excellent drawing practice to work from life where possible. You have to look very carefully at your subject, but the information you need to make an exciting drawing will be there in front of you.

Using the hatching technique

Hatching is great for many types of subject matter, from landscapes to animals, and is the perfect technique to use for grasses blowing in the wind.

With any landscape, it can be useful to start at the top. Here I hatched in some sky, distant hills and trees. I smudged them slightly, to give a feeling of them fading into the distance. For the grasses I hatched ochres and yellow-green earth colours to create a base to work into, thinking about the grasses blowing in the wind as I made my marks. Leaving some of the paper showing through, I introduced blue-greens and brighter light greens.

For the last stage, I increased the range of tones, using a few darker blue-greens, and strokes of lighter yellows and creams for flowers. The use of warmer colours in the foreground, and cooler lilacs in the distance, creates more depth.

This detail shows how I have used layers of hatching to describe the grasses, from ochres and mid greens as first layers, and then brighter golden yellows over those, adding more yellows in the foreground.

You can just see the darker green of the trees at the far edge of the field, and some white marks to hint at flowers over the top. It is the varying combinations of colours and marks that give a feeling of grasses blowing in the wind, catching the sun.

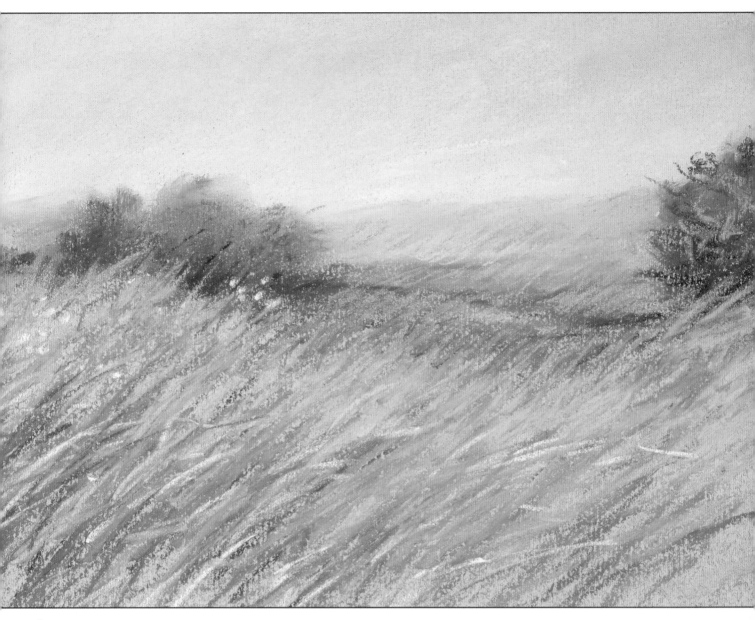

Grasses

Varying the pressure

One of the many joys of working with pastels is that it is tactile, meaning that you hold the pastel in your hand, and apply it directly to the surface. This means that you can press very hard, or very gently. You can make sharp, aggressive marks, or just let the pastel stroke the surface. In other words, you can change the energy of the marks that you make, and by doing so, capture on paper the energy of your subject.

1 Applying more pressure to the pastel will result in a relatively thick, heavy line.

2 Using less pressure will give a finer, fainter line. With soft pastel, you barely need apply any pressure at all; the pigment is so rich that you can simply graze it against the surface.

3 You can also vary the pressure while you draw the line, which results in more lively drawings.

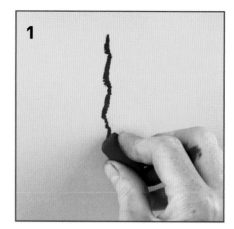

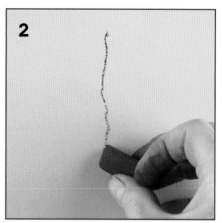

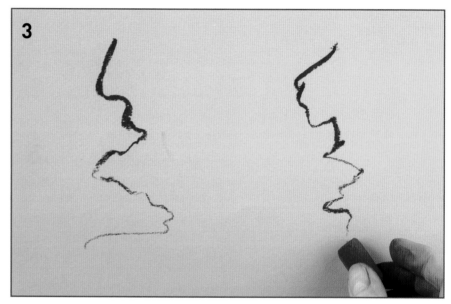

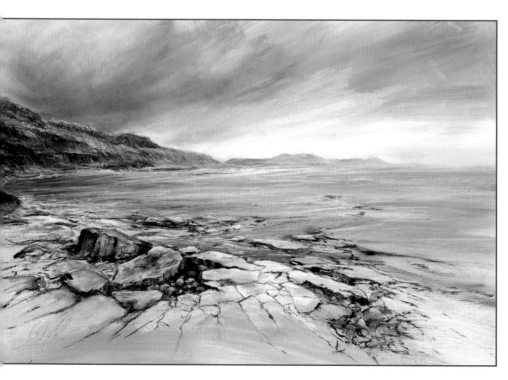

In this painting I used twisting, linear marks to describe the rocks in the foreground. I contrasted this technique with softer smudging in the distance. It is this variety of mark making that can bring your work to life.

Pressure and different materials

As well as the change of pressure that you apply, you can change the grade of pastel you use to make different qualities of marks. To start with, experiment by picking up a pastel, and alternating between pressing hard and just letting the pastel touch the surface. It's a bit like playing a musical instrument, loud and soft.

Next, try out different grades and types of pastel and do the same thing. To achieve different effects, get a feel for when you need to change your pressure or when you need to change to a harder or softer pastel. Or maybe combine them? The more you experiment, the more you will discover.

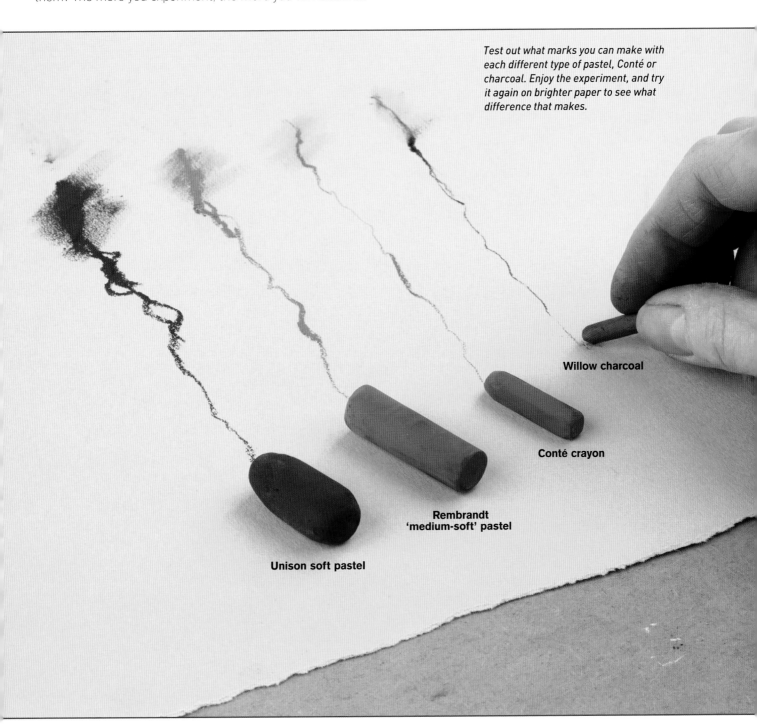

Test out what marks you can make with each different type of pastel, Conté or charcoal. Enjoy the experiment, and try it again on brighter paper to see what difference that makes.

Willow charcoal

Conté crayon

Rembrandt 'medium-soft' pastel

Unison soft pastel

Textures using varied pressure

The technique described on the previous pages works for all sorts of subject matter, but if you practise by using subjects that you have in front of you, you have a lot more information to inform your drawing process. So as well as looking at your leaf, or plant, or feather, hold it in your hand to feel how heavy it is, and touch it to feel the texture. Is it light and fragile, or heavy, hard and spiky? By feeling these things, you are better equipped to capture its essence in your drawing.

In these examples, very little colour is used, so that the energy is captured using tone and pressure.

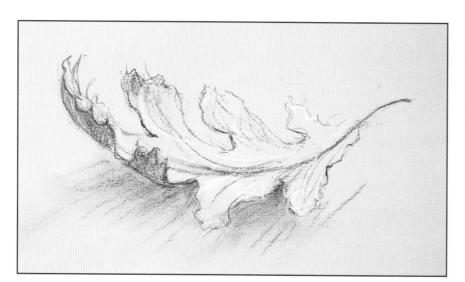

Light and fragile textures

Autumn leaves are perfect subjects to suggest fragility. Sketch the leaf using brown and white Conté crayons, using very little pressure at the ends of the leaf, but press slightly harder where there will be a shadow.

Heavy and hard textures

To create weight and strength, we can press harder, and use softer pastels with more pigment in them for darker colours.

1 Sketch this dried artichoke head with a brown Conté crayon to get a feel for its form, seeing how the petals curve around and overlap each other.

2 Strengthen the petal drawing with a soft dark brown pastel, which is smudged in places to create solidity and a soft base to work over.

3 With a black harder pastel or Conté crayon, put some darks into the shadows. To see where these areas are, look at the object through screwed-up eyes, which makes the tonal contrasts appear more obvious.

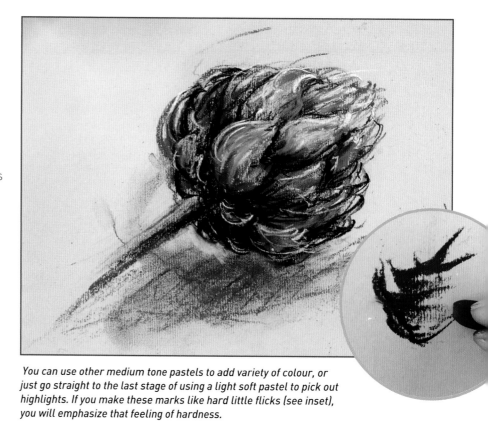

You can use other medium tone pastels to add variety of colour, or just go straight to the last stage of using a light soft pastel to pick out highlights. If you make these marks like hard little flicks (see inset), you will emphasize that feeling of hardness.

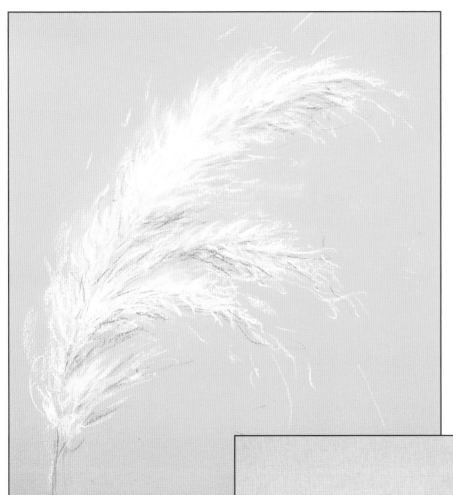

Soft textures

The feel of this fluffy pampas grass is created with a soft creamy pastel, applied in a few layers and then softened with my fingers. A few strokes of brown Conté crayon are smudged in to add gentle shadows. Next, lots of rubbing with fingers; and also an eraser to create super soft areas.

Sharp and prickly textures

Teasels are so prickly it is painful to hold them. To create this sensation, we can make light, spiky marks. This is explored in more detail overleaf.

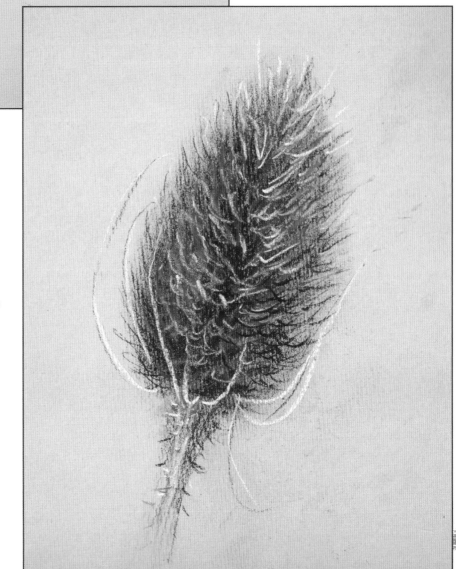

Teasel

This demonstration shows how you can combine different media; using the strengths of each to give a striking effect. We will use soft pastels, Conté crayons and pastel pencils to create a drawing that has depth, and also has the light prickly feel of a teasel. However, we are not trying to copy the teasel exactly. Instead, we are using our marks to create an impression, remembering that less is more. The pastels I used were Unison brown earth 6, brown earth 29, grey 20 and grey 28.

You will need:

Pastels: Dark brown, mid brown, light brown and white
Conté crayons: Brown and white
Pastel pencil: Dark brown
Craft knife

1 Sketch out the basic shape using a brown Conté crayon. These very hard pastels are excellent for detail, and being so hard, they leave a very faint line if used lightly.

2 Use soft pastels to build up rich, dark tone quickly. Being so soft, they also smudge in easily.

3 Soft pastels give body and depth, while Conté crayons give precision and detail. Hard pastels fall in between and are excellent to 'bridge the gap' so that it's not obvious where one medium starts and the other begins. Use a hard pastel to add finer marks around the edges, to suggest the overall texture.

4 Soft pastels overlay readily with the lightest of touch, so they are excellent for adding marks within the shape. Using the edge will allow you to get surprisingly fine marks.

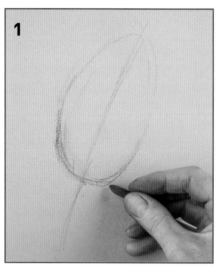

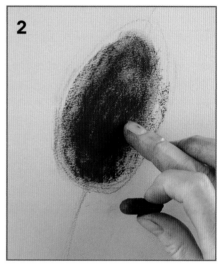

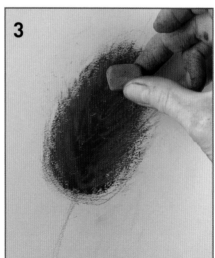

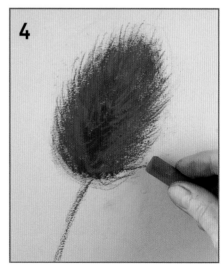

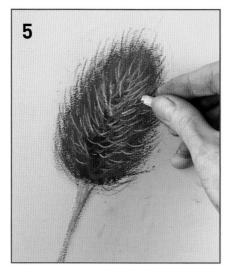

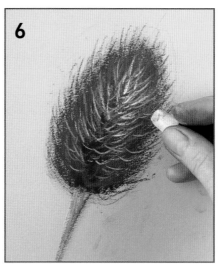

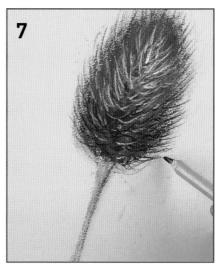

5 Use a white Conté crayon to make the initial marks for the highlights. The fine marks give the impression of spikiness, but they are very faint.

6 A white soft pastel can be used to strengthen the light Conté marks in places. To get a sharp edge, you can break a bit off the pastel, creating a shard. You do not need a point, just a sharp edge to create detail, and a light touch.

7 Pastel pencils can be sharpened to a point, and so can be used for very precise marks. Because they contain a lot of binder to hold the pigment together, the marks will not be as strong as those made with a pastel (see page 43). For this reason, they are best used on the edges for the finest prickles.

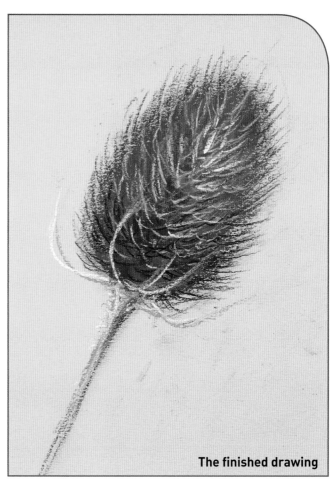

The finished drawing

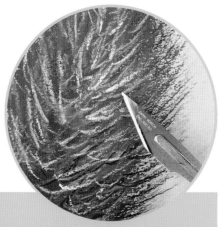

Tip

You can use a craft knife to gently remove the layered pastel on the surface in a more controlled way than using a scraper. This is useful if detailed areas get clogged up, or to create sharp marks.

Other ways of using the varied pressure technique

All of the techniques for varying pressure can be used for drawing and painting animals with pastels. This dog was created using a combination of the teasel techniques on her face. I softened underlayers of soft pastel, and then used sharper Conté crayons and pastel pencils to get the wiry textures of her fur.

I used smudging and softening techniques on her ears and eyes, often starting with darker shades, and adding lights on top. I used charcoal in places under the nose and around her eyes.

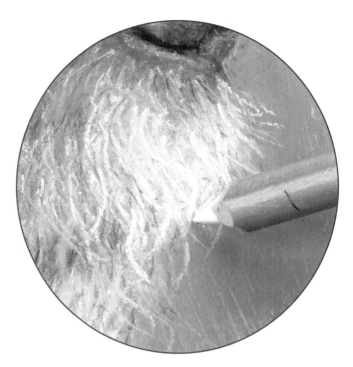

Pastel pencils can be used to hatch the finer qualities of fur and hair over the pastel undercolours. This can create a beautiful, subtle effect, but while still having the strength, energy and depth of colour provided by the soft pastels. Pastel pencils make fine hairline marks, so are great for whiskers.

For soft dog ears, put on several layers of rich, soft pastel to fill the surface, and soften with your fingers.

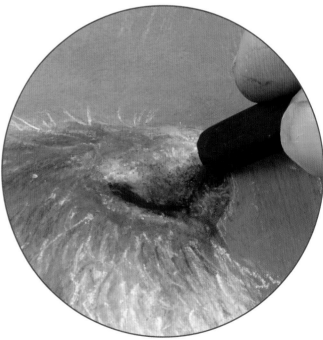

Black Conté crayon is ideal for sharp, dark details, such as the shadow areas of the nose.

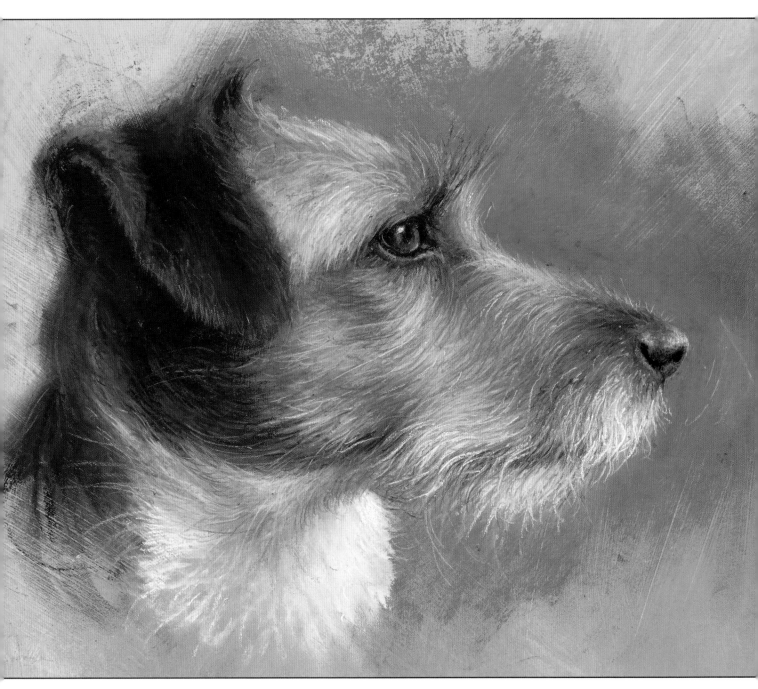

Flick

Twisting

Linear work with energy

This technique is a way to really feel the difference in how much more you can do with pastels than you could with pencils, letting you draw in an expressive and fluid way. It requires a loose, ever-changing grip, and constantly changing pressure.

It also works well with harder pastels and Conté crayons, but soft pastels can be used in this way on a larger scale.

It is a good way to draw from life, and capture movement, and indeed it works beautifully for most natural forms, from plants to animals, and hair and clothing on figures.

Trees, rolling hills, rocks, and water can all be brought to life with a few twists and turns of your pastel.

1 Hold the pastel in the middle, and lay it flat on the paper. Drag it along the length of its edge to make a broad mark.

2 Try changing your pressure, and letting the pastel twist and turn to produce a dancing line.

3 Let it come up onto its end in places, then go back to having its whole length in contact with the surface. Let your pastel dance.

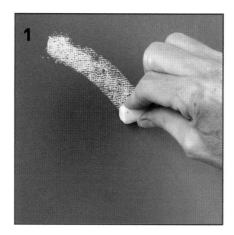

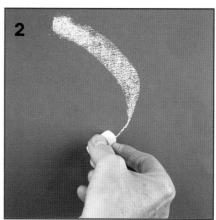

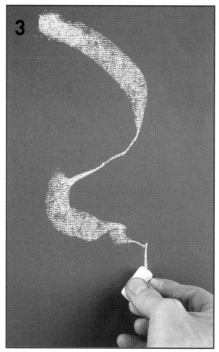

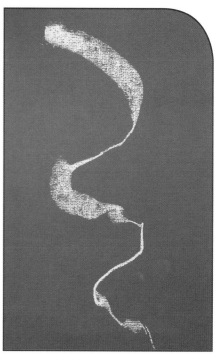

The finished effect

This technique gives a variety of marks; try combinations of broad sideways strokes and long linear strokes.

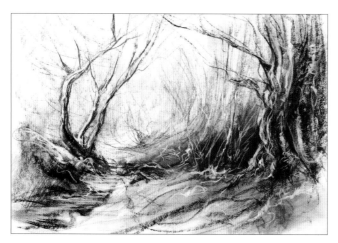

Twisted Trees

Sketch in brown, black and white Conté crayon.

Go with the flow

Plants make wonderful subjects to practise how to get a feel for the flow of lines. Recognizing and using lines of flow is something that will bring your work to life, rather than just producing exact copies of photographs. These techniques work well if you stand up and use all of your arm, so that you can move your body to create a sense of movement and direction.

Using the twisting technique

I love drawing and painting onions, as they have a combination of simple, solid form and twisting lines; with places where the dried skin breaks away and the stalks have shredded. They are good fun to practise with, as it doesn't matter if you don't get your drawing to look exactly like your subject; you are just trying to capture the essence of the onions in front of you.

You can draw lines and tones at the same time, by varying which part of the pastel that you use as you make your marks. Even as you start to add layers of colour, you can keep twisting and turning your marks.

This detail shows how more intense soft pastel colours have been worked over the initial layers. Enjoy following the twisting lines – it doesn't matter how much colour you add in; just have some fun.

Onions

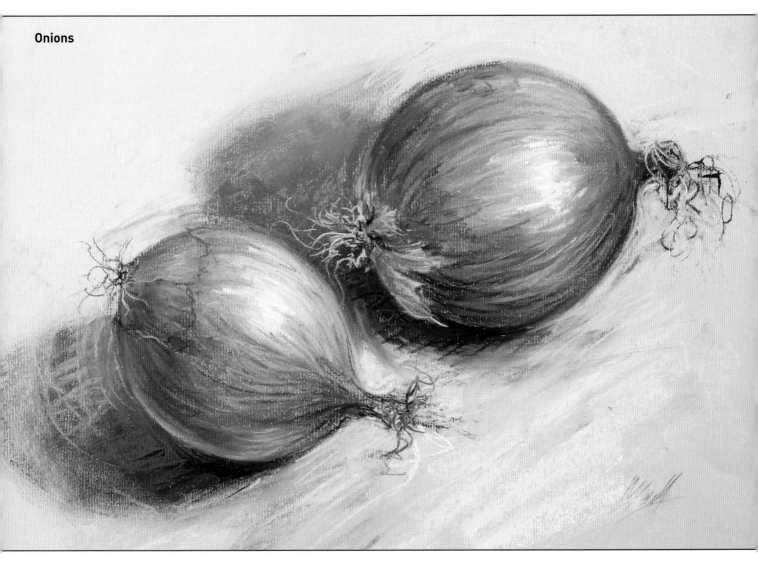

Other ways of using the twisting technique

In this painting the hard, heavy rocks are in shadow, and the light, delicate trees are catching the sun. The twisting technique has been used for the rocks in the foreground, for the tumbling river and for the trees.

 The background areas were smudged and softened so that they receded into the distance, and then I used twisting marks to create a sense of drama in the foreground.

Notice how I have twisted light marks with a soft pastel to describe the sunlight catching the tree trunks over the dark shadowed rocks.

The Light in the Coombe

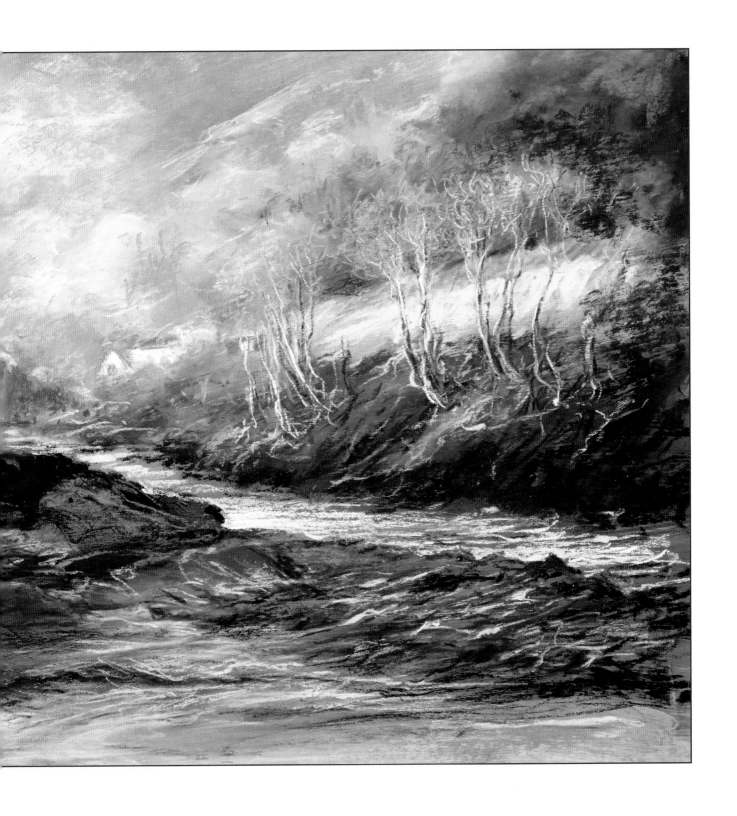

Using pastel pencils for drawing

Like most pastel products, pastel pencils contain pastel that is a mixture of pigment and binder. In order for the pigment to be strong enough so that it doesn't crumble too easily, there is more binder in the mixture than with actual pastels. This means that the pigment itself is not as vibrant. It can be very tempting to reach for your pastel pencils every time that you need details in your pastel work, but you have to be careful that they don't dull your work down. However, they are very useful if you want gentle changes to an area, as described in the hatching section, but they can also be used very effectively for gentle linear drawing work.

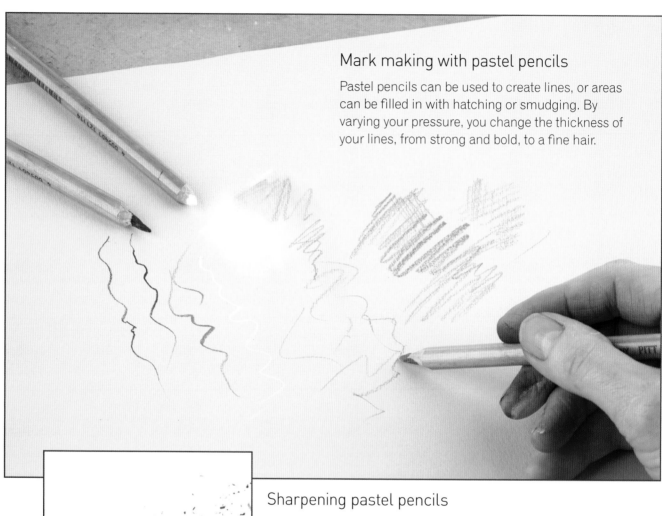

Mark making with pastel pencils

Pastel pencils can be used to create lines, or areas can be filled in with hatching or smudging. By varying your pressure, you change the thickness of your lines, from strong and bold, to a fine hair.

A blunt pencil – is pointless!

Sharpening pastel pencils

Sharpening pastel pencils can be a tricky process, as the pastel part is so much softer than the wooden casing, and so can break very easily. I find the best way to sharpen mine is with a sharp scalpel or craft knife.

Hold the pastel pencil and knife as shown, keeping your thumbs together to stabilize them. When cutting, keep the blade still: move the pencil, rather than the blade, back and forth. This makes it much easier to increase and decrease the pressure that you apply, in order to adjust as you cut through the wood to the softer pastel part.

In a World of his Own

Red ochre, brown and white pastel pencil on Canson paper. Pastel pencils lend themselves to gentle subjects, such as children.

Hide and Seek

This piece was drawn with pastel pencils, and then worked into with some soft pastel. However, areas of the drawing were left untouched, as the lines alone were enough.

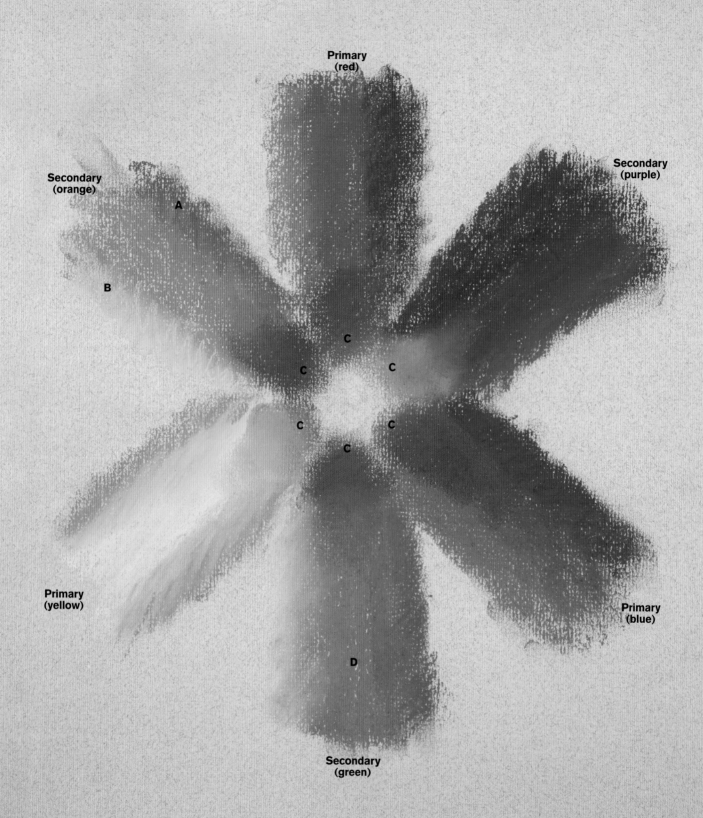

Primary
(red)

Secondary
(purple)

Secondary
(orange)

A

B

C

C

C

C

C

C

Primary
(yellow)

Primary
(blue)

D

Secondary
(green)

The colour wheel

Colour

The colour wheel

Most artists and paint manufacturers base their colour knowledge around the colour wheel, which in its simplest form has three primary colours, red, yellow and blue, and the secondary colours that result from mixing each primary with the one next to it. Mixing red and yellow results in orange; red and blue make purple; and blue and yellow make green. The primary colours themselves cannot be mixed, they have to be purchased.

Notice how each primary has a secondary sitting opposite to it, so red is opposite green, blue is opposite orange, and yellow is opposite purple. These pairs of colours are known as complementary colours.

Mixing colours In this simple pastel colour wheel, each colour has been hatched into the colour next to it to mix them together. To make a red-tinged orange, I have hatched red into the orange (A). On the other side of the orange, I have mixed orange and yellow to make a yellow-tinged orange (B). As you go round the colour wheel, mixing each colour with the one next to it, you get ever-changing blends of pure, clean colours.

Mixing neutrals The brown, muddy colours in the middle of the wheel (C) were created by smudging the complementary colour (i.e the colour opposite it on the wheel) into the first colour. Blue, for example, was smudged into the orange. You can see how the complementary of a colour neutralizes it. We can use this to great effect in our paintings.

Different mixes for different results There is more than one way to mix a colour. If we want to make a bright, clean green, we can use a green-tinged yellow, and a green-tinged blue, which are both fairly close on the same side of the colour wheel (D). However, if we mix an orange-tinged yellow with a violet-tinged blue, we are combining two colours that are nearly opposite on the colour wheel, which will result in a dull brownish green.

Think twice before you blend!

If you put similar saturations or intensities of complementary colours against each other, they will give a dazzling effect. However, if you smudge them together, the result will be a mud colour, as they neutralize each other.

Using pastels in colour

We need to look first at how pastels differ from using other types of paint. With watercolour, oils and acrylics we can start with a very small palette of the three primary colours, black and white. However, we need a much bigger range of pastels to get started – although we can mix colours, we have to mix them on the surface as we draw and paint, rather than on our palette before we apply them. In order to avoid an overworked and clogged-up surface, we start with a bigger range of colours and tones to choose from.

On page 14 we looked at a set of thirty colours to get started, that includes lights, mediums and darks, as well as saturated and neutral hues.

Tone and saturation with pastels

We started at the beginning of the book by drawing in monochrome, and thinking about tonal differences (see page 22) – in other words, concentrating on lights and darks. Life gets more complicated when we are dealing with colour as well as tone. We have to think about tonal differences, but also differences in saturation.

Tone How light or dark the colour is.

Saturation How pure the colour is. Saturated pigments are very bright to look at. Better quality pastels use purer pigments so will be more saturated than cheaper ones.

Tonal ladder in blue

Think back to the tonal ladder we did with black and white on page 20. This is a tonal ladder using blues, which I have made in preparation for painting a sky. I have picked out from the box four blue pastels, ranging from light, to medium and dark, and smudged them where they join.

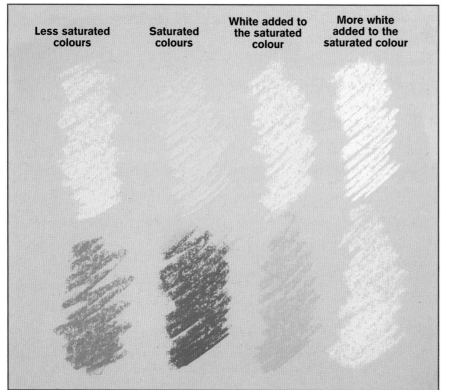

Less saturated colours	Saturated colours	White added to the saturated colour	More white added to the saturated colour

Saturation

This shows the difference between saturation and tone, with eight different pastel colours. Second from left are a saturated yellow and purple.

To the right are versions that are lighter in tone, which means that white has been added to the mix during the production process of the pastel.

To the left are less saturated versions of the two colours. In the production process these will have had white added but also other colours, so the result is less pure.

Ways to mix pastel colours

Even though we have quite a few colours to start with, we still need to mix pastels on the surface to achieve subtle effects and beautiful paintings.

You can mix by hatching, smudging or by laying one colour over another. The best way to try out the methods is to do your own experiments to see what your own pastels can produce. With better quality pastels, you will have purer pigments, which will result in fresher mixes. Good quality pastels also come in a wide range of tones, from deep darks to bright lights, but also will range from very saturated pigments to subtle hues.

The painting below is an example of mixing by laying saturated colours over one another, then smudging to create more subtle blends.

Mixing by hatching

Mixing yellows, greens and blue-greens by hatching colours together. This works well for grasses.

Mixing by smudging

I sketched this landscape using the bright colour swatches shown on the left. By overlaying them and smudging them together with my fingers, I created a subtle and misty landscape.

This shows how mixing and blending can reduce the saturation of the colours that you are using. This is why you should never be scared to use pure colours; as with all types of paint, you can mix muted colours from saturated pastels but you can't mix saturated, pure colours from muted pastels.

Choosing colours to create distance in landscapes

Landscapes are a perfect subject to learn about which colours to choose and how we can mix them together. With a landscape we are trying to create depth and distance, and we can do this in two ways; by varying the tones (lights and darks), and by varying the saturation of the colours (how pure or muted they are). To help understand this, let's remember how we worked with monochrome, (black and white) earlier in the book.

Distance and tone

It is easy to forget about the importance of tone when we enter the exciting and beguiling world of colour. However, if we want to create depth in our painting, an easy thing to remember is that anything that is closest to us will have the biggest range of dark to light. Anything in the distance will have less of a tonal range, because there are more particles suspended in the air between the eye and what is in the distance. This result is that the tones become softened and more muted, an effect called tonal recession.

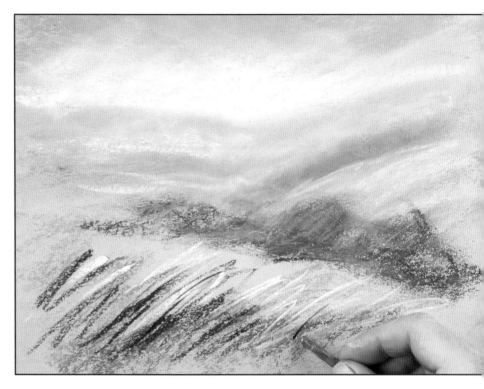

Tonal sketch

It can be helpful to make a quick and fairly small black and white sketch before you reach for your colours. Using charcoal and white pastel, make a simple sketch of the landscape as shown. Notice how the biggest contrasts of dark and light are in the foreground grass; while the distant hills and sky are smudgy midtone greys, from the middle of the tonal ladder.

Creating distance with colour

If you are painting a landscape in colour, and want to create the feeling of distance, there are some simple rules to get started:

Purity Purer, more saturated colours tend to appear to jump forward, and mixes and neutrals tend to recede.

Colour temperature Warm colours such as reds and yellows also appear to come forward, while cooler ones – blues and purples – appear to recede.

To achieve the illusion of tonal recession, you can use purer versions of yellows, oranges and yellow greens in the foreground, changing to bluer greens in the middle distance and cooler, greyer mixes of blues and purples in the distance. The colour swatches on the right illustrate this.

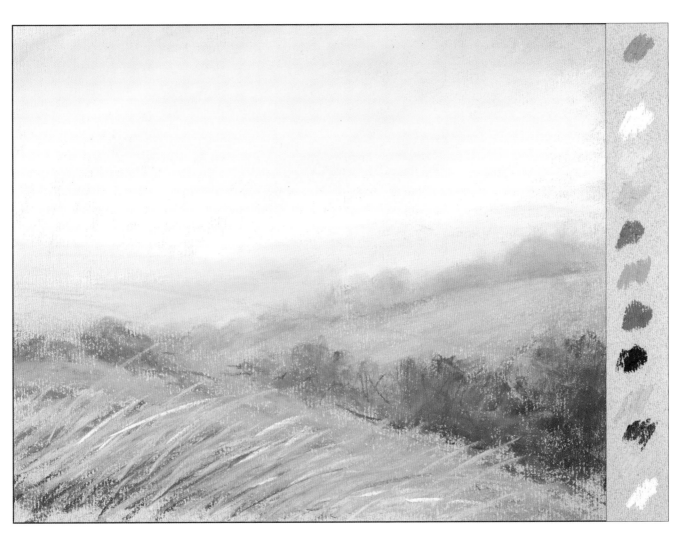

View from the Cornfield

This painting shows how to create a feeling of distance in a landscape, by choosing warmer, more intense colours in the foreground, and cooler, more muted ones in the distance, and the colour swatches on the right show the individual colours used.

To further enhance the mistiness of the distance, I have softened and smudged the pastels together more. Some of the brighter yellow greens have been neutralized by hatching and smudging in cooler blues and lilac greys. Sometimes artists call this 'knocking it back', and it is very easy to do with pastels.

Colour palette

I find it extremely useful to try out colour swatches first, on the same paper that I will be painting on (see above right). The colours I used were all Unison pastels, from the top: blue green 3, blue violet 9, grey 28, add 31, blue violet 2, grey 34, yellow green earth 9, green 15, dark 8, add 9, brown earth 29, green 12 and grey 27.

Rolling Fields

You will need:

Any pastel paper: Grey

Pastels: bright blue, light blue, very light blue, lilac, grey-lilac, grey-blue, light green, mid green, dark green, light yellow, cream, and warm brown

For this landscape, the colours are richer in the foreground and washed-out and hazy in the background to create depth and distance. The core pastels I used were: blue green 3, blue violet 9, add 31, blue violet 2, grey 34, yellow green earth 9, green 15, dark 8, add 9, brown earth 29, green 12 and grey 27.

1 Use charcoal to lightly mark out the initial shapes very simply. Leave plenty of space to one side of the image, for you to test your colours.

2 Choose a nice bright, saturated blue for the top of the sky. It is always important to test your colours on the surface you're using; so hatch a bit of colour on next to where you'll use it – in this case, at the top of the painting.

3 Pick a lighter blue for the middle of the sky and hatch an area next to the middle of the sky. Overlap the hatching with the previous blue.

4 Pick a still lighter blue for the bottom of the sky and repeat the process near the horizon.

5 Pick some soft colours – midtone and less saturated – for the hills; scribbling them on under the sky colours. I'm using a lilac and a grey-lilac because misty hills in the distance appear blue-violet. You may find that you don't have the perfect colour pastel; this is why we're hatching them into one another – when mixed with other colours on the paper, you can alter the hue; the hatching lets us test this.

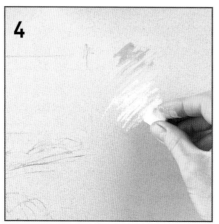

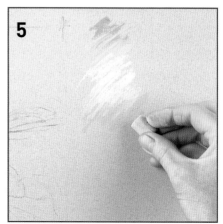

6 Having picked cool colours for the sky and distant hills; now pick colours to make the landscape gradually come towards us: a grey-blue for distant trees; light, medium and dark greens for the fields as they get closer; and a selection of bright greens, yellows, browns and creams for the foreground.

7 With your colour test in place, stand back and assess. Here, I think the grey-blue looks too strong, so I hatch a little of the lighter blue and grey-purple into it until it looks correct.

8 Now let's start the painting itself. Apply the three blues, starting with the most saturated at the top, and getting lighter and more neutral as you work down – that is, as the sky recedes. Smudge them in.

9 Using the midtone grey/lilacs for the hills in the distance, overlap the pastels over the bottom of the sky. This helps the colours to blend and avoids obvious breaks as you smudge them in.

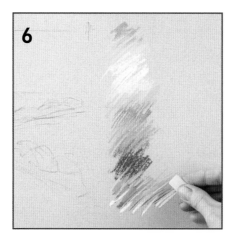

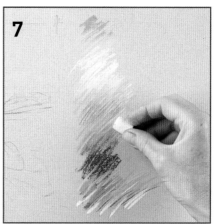

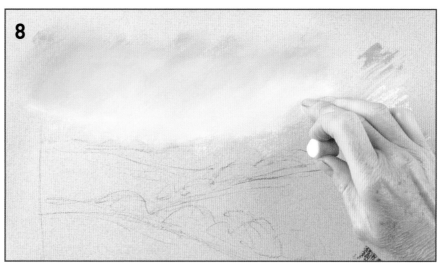

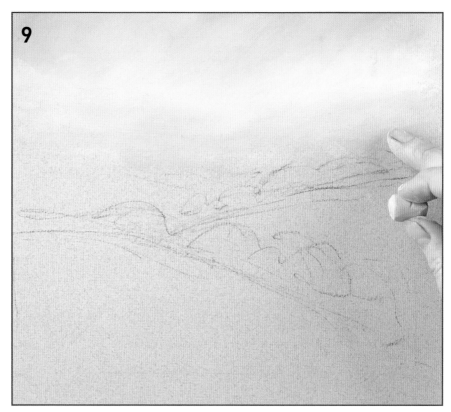

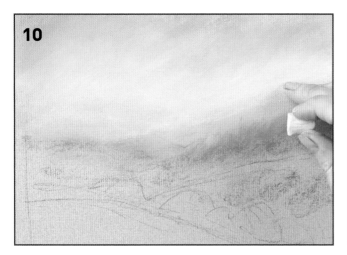

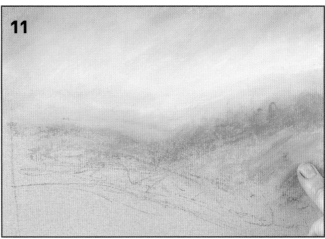

10 The middle distance has light, bluish greens, applied with soft gentle marks, and then smudged in. The sky and distant hill colours are blended into the greens.

11 Brighter, more saturated greens are applied with more vigorous marks and more pressure in the fields.

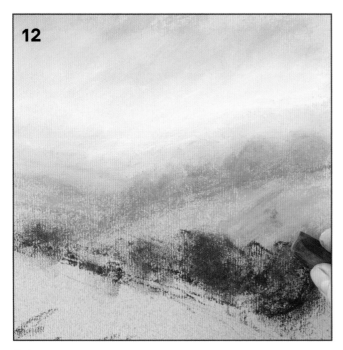

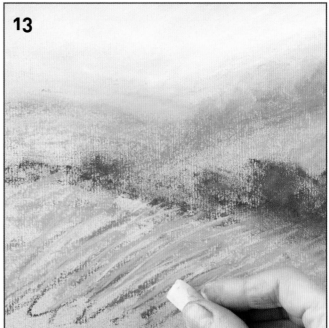

12 Add darker greens and some brown to create the trees in the foreground, using the pastel on its side to make broader marks, slightly swirling to convey the shape of the trees. Use more pressure as you come further forward in the landscape to make stronger marks.

13 To finish, use the hatching technique to introduce darker greens and lighter creams in the grasses nearest to us, as well as yellows and some warm browns, as warmer colours will make this area appear closer to us. Use more pressure with your marks to strengthen them in the foreground. Next, stand back and assess your work. If necessary, make any adjustments (see step 7).

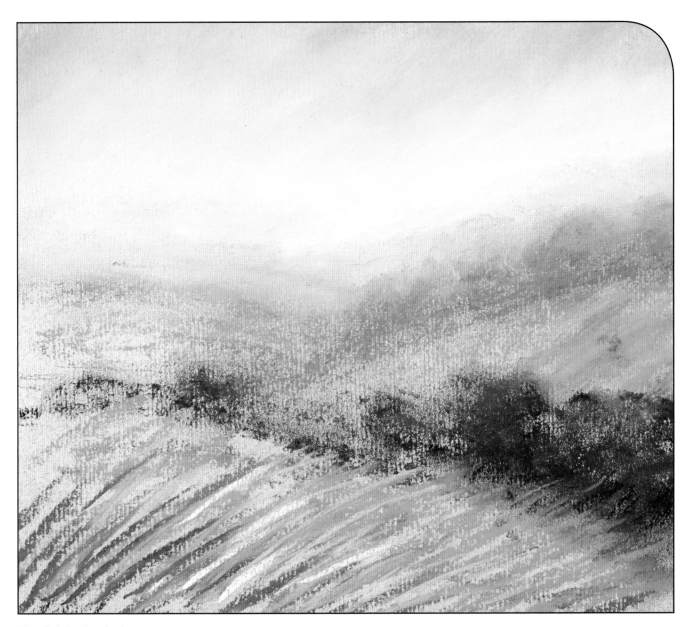

The finished painting

To create the sense that the foreground is closer to us, I have used a combination of four devices:

- *More saturated colours,*

- *Warmer colours,*

- *A greater range of tone,*

- *More pressure in my mark making.*

Surface colour and tone

Choosing your piece of paper to start a pastel painting can seem difficult at first. Good-quality pastel papers come in a huge range of colours, ranging from bright to neutral, and light to dark.

In this section we are going to look at how the colour of paper or surface that you choose will affect your work, and also the importance of the tone of paper. There is no right or wrong, but your choice of surface colour will affect the mood of your painting.

Choosing your pastel palette

It is always good to test out your colours on the paper you are thinking of using before you start your piece. Look at these colour samples, using the same four colours on various papers. Notice how the colours look dark on a lighter paper, but light on a darker paper. In some cases it is hard to believe they are the same colours.

I would strongly advise against using white paper when you are using pastels. They are far easier to use on midtones, which may seem strange if you are used to painting with other media such as watercolour. The best way to understand this is to get a few different colours and tones of pastel papers and try it out for yourself.

Changes to your palette

As pastel colours behave so differently on different colours of surface, we sometimes have to change our palette slightly. For example, looking at the swatches here, to make the blue-green look dark enough on the brown paper I would need a darker blue-green than the one shown.

We usually need to go stronger and darker with the pastels we choose to create depth and shadow on dark surfaces.

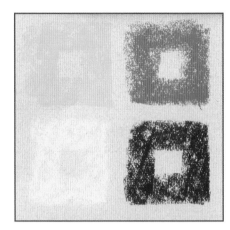
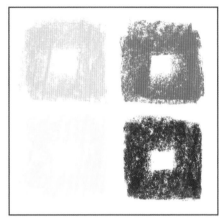
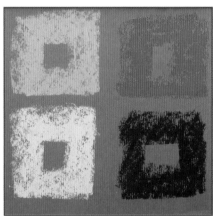
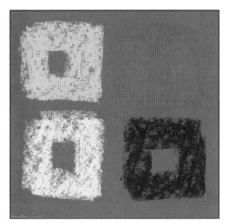
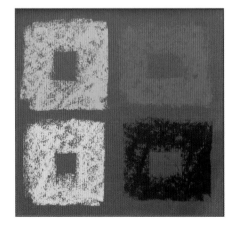
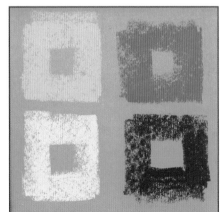

Mood

The colour of our paper will be part of our palette, and can have a huge effect on the mood of your piece. You may want a surface that is bright and intense, to create lively work, or to use something neutral to create a feeling of calm. I like to use a terracotta colour for my beach scenes, which provides a bright complementary colour under the blues, but also a sympathetic colour under skin tones. For portraits it is a good idea to use a colour and tone that are related to the skin tones of your subject. The choices you make will come with experience, and If you are not happy with a drawing or painting, and you suspect it was due to the colour or texture of your surface, it is a great exercise to do the same piece of work again on something else. It will often be much easier to produce and feel a lot better on a different colour.

Darker tones of paper can give a dramatic effect. The beauty of pastels is that you can work from dark to light, or light to dark, meaning that as you can build up layers, and are not reliant on the paper showing through to create your light tones, as with watercolour.

Contrast and depth

This painting, Love me Tender, uses a dark blue background to create an intense depth of emotion. The highlights are picked out by bright stage lighting to contrast strongly with the dark background.

Passion and drama

A deep red background adds passion and drama to Carabosse.

Experiment with the mood you can create

It's a good exercise to do similar or identical sketches on different coloured grounds, as this lets you compare how the pastels behave visually. It helps if you pick something simple to draw.

Although we have chosen our surface as a background colour, we still usually need to add some background with pastel, in order to describe the form of our subject. Nothing exists in a vacuum, so adding some dark and light background in certain places will help to 'bring out' your subject so that it looks real and three-dimensional.

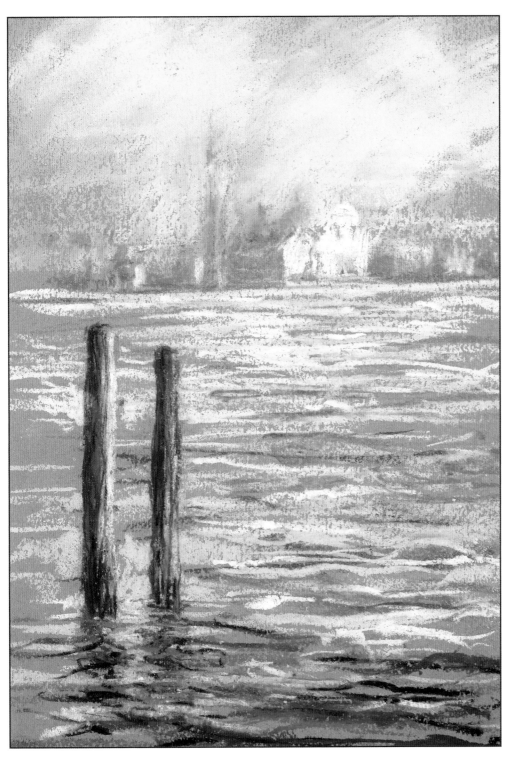

Dark or light?

These two sketches of Venice feel like they were made on two different days, with different weather conditions. Using a darker tone of paper (see opposite), emphasizes a sense of drama, while the midtone paper (on this page) creates the feeling of a calmer and sunnier day. This is partly because when sketching the one on this page, I used a lighter palette of pastels, especially for the water, but also because the midtone paper is a warm sandy brown, which creates a brighter mood.

Landscapes

Landscape painting is a huge subject, so to make it simpler, I have divided it into sections, each one looking at specific subject matter.

 An important thing to remember is that the landscape changes constantly depending on the weather conditions, the time of day and the time of the year. So we are not just capturing the structures that we see, we are also trying to convey what the atmosphere is like to the viewer. We looked at ways to mix colour to create atmosphere and distance in the colour section. We are now going to focus on how to change our mark making to draw the features and forms of the landscape.

Moorland Stream

This painting, reproduced here at actual size, is a good example of tonal recession but also mark making with pastels. To create that feeling of distance on the misty moor, I have used yellow ochres in the foreground, and contrasted them with lilacs and cool greys in the distance.

I have varied my marks, from soft smudging in the misty distance, to pressing hard with angular strokes for the rocks, and swirling, dancing marks for the water.

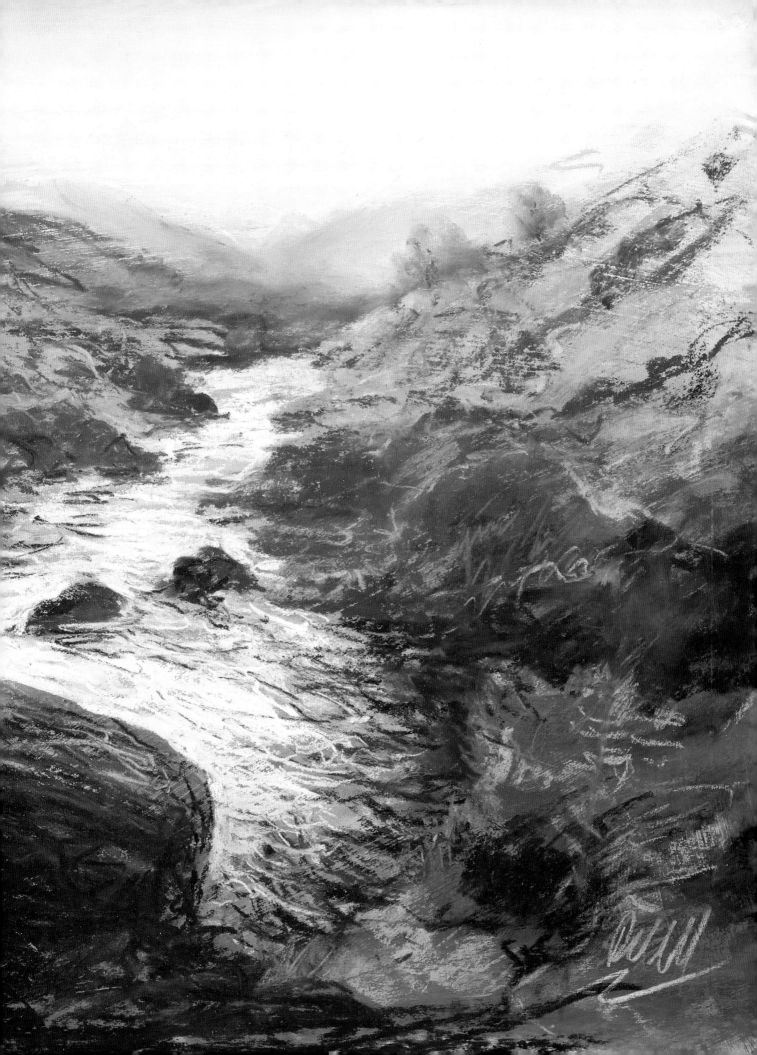

Hills: The lie of the land

There aren't any hard edges on rolling hills, so we can let the pastel roll and twist to describe the flow of soft curves.

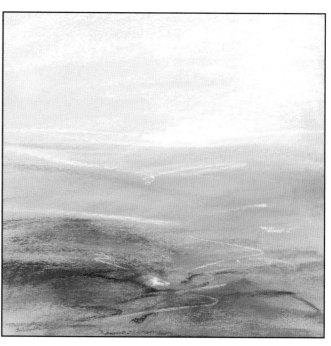

Rolling hills charcoal sketch

It is very useful to do tonal sketches to get a feel for what you are going to paint. I like to use charcoal and a cream or white soft pastel. I can twist and turn my marks to get a feel for the rolling hills, and smudge to create a feeling of distance.

Rolling hills colour sketch

A quick ten-minute sketch using a limited palette, capturing the softness of the rolling hills as they recede into the misty distance. Remember 'less is more': by leaving out details, you can convey more atmosphere.

Mark making for rocks

Rocks are hard and heavy, often with sharp edges. By using the pastel on its edge and making jagged marks, and pressing hard in places, we can capture that energy.

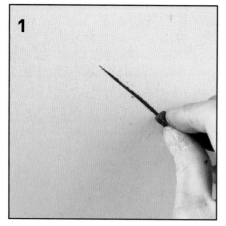

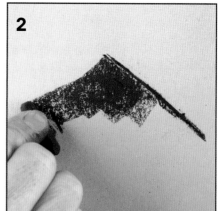

1 Using the pastel on its edge and pressing hard, draw the pastel to make a deliberate clear mark.

2 You can add the dark shadows of rocks by drawing the edge of the pastel away from the line. Again, press hard and make a strong movement.

3 Using this combination of techniques enables you to quickly build up the faceted surface of a rocky outcrop.

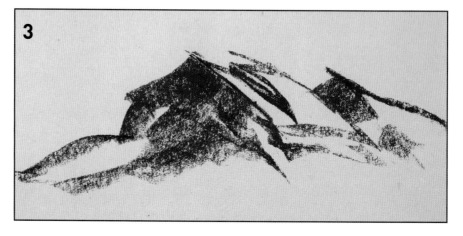

Tonal contrast and sharp edges

To create the effect of strong facets I use a big tonal contrast, pressing hard where I want the darkest shadows or brightest highlights, giving dramatic contrast.

Tip

To get sharp marks, you do not need a point, just an edge. If you drop a pastel on the floor and it breaks, keep the shards. They will come in very useful for sharp marks and details.

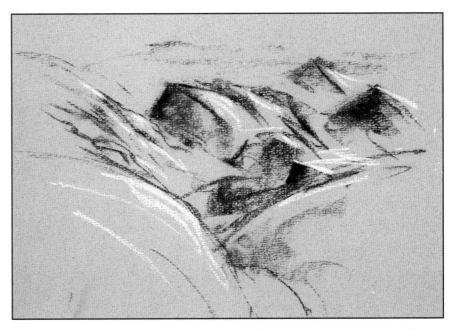

Moorland rocks sketch

Here the sharp edge of the cream pastel has been used to create highlights.

Cliffs at Tintagel

This sketchbook piece used charcoal and white pastel. I made sharp, hard jagged marks to capture the rocky cliff in the foreground, but applied less pressure for the cliffs in the background, to create a feeling of distance.

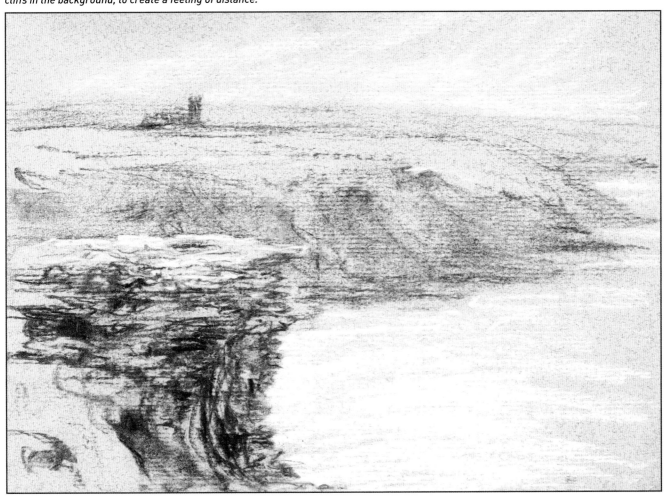

Rocky Tor

Before I start any landscape painting, I have to think about the tonal contrasts, and how I will create a feeling of atmosphere. Notice the strong tonal contrast in the foreground, but in the background there are misty midtone greys. I want to convey a feeling of height, so need to make the difference between foreground and background more pronounced than usual.

You will need:

Winsor paper: Cool blue

Willow charcoal

Pastels: Mid-blue, light blue, pale grey-lilac, light blue-grey, lilac, yellow earth, light olive green, mid olive green, very dark blue, slate grey, very dark brown, dark green, raw sienna and pale warm yellow

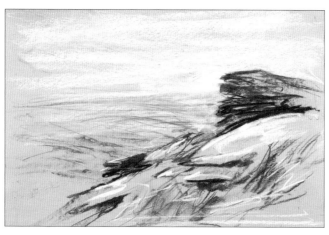

Thumbnail sketch

A quick thumbnail sketch in charcoal and light soft pastel will help you get a feel for your subject and the dramatic composition.

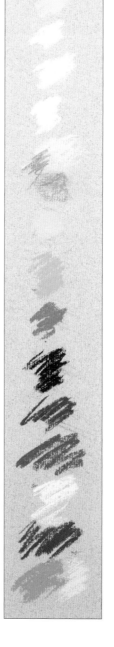

Colour palette

Unison blue violet 9, blue violet 7, add 31, grey 27, blue violet 2, grey 34, brown earth 32, yellow green earth 9, green 15, dark 18, brown earth 6, add 51, add 31, dark 8, grey 20, yellow 17.

Source photograph

To choose the paper colour, I held the photograph up to the paper, to check that the photograph sits happily within it: remember that the surface of the paper is part of your picture, and the colour of it is part of your palette.

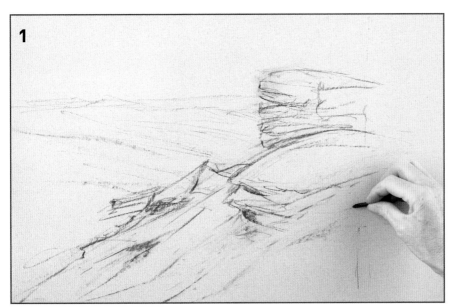

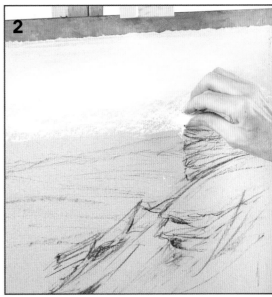

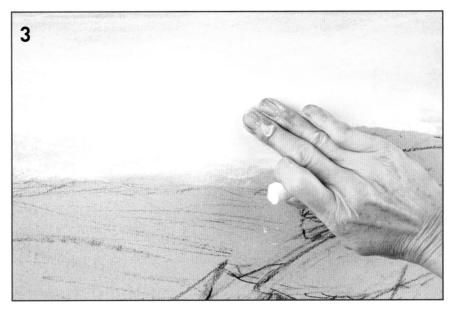

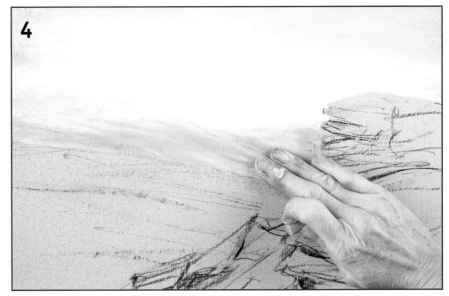

1 Referring to the source photograph and preparatory sketch, use charcoal to establish the position of the main shapes on the paper. Reserve some space on the paper for your colour tests. Don't try to copy the photograph – just try to capture the essence of the lines. Use sweeping motions for the rolling hills, and block in the foreground rocks lightly.

2 The sky is quite pale, so when choosing colours, even the top of the sky is relatively light. Start to paint in the sky using a mid-blue and a light blue using the edge of the pastels. When you come to the rocks, use the edge of the pastels with a strong stroke to make obvious linear edges.

3 Smudge in the sky as you go, and introduce pale grey-lilac towards the horizon. Hint at clouds with the cream pastel, using it on its side. When smudging, use energetic motions that follow the line of the hills.

4 Use light blue-grey to paint the distant hills. Smudge lilac pastel over the hills in order to knock back the tone. Again, let your smudging follow the sweep of the hills.

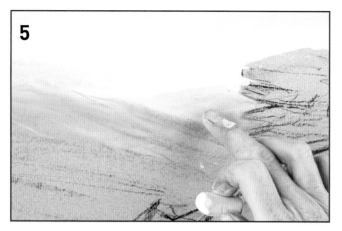

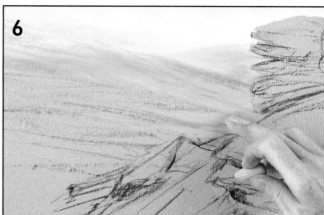

5 In between the hills, add a highlight using the sky colour (pale grey-lilac). Soften this in to help differentiate the hills.

6 Work into the midground with the light blue-grey, following the lie of the land, and overlay some of the gaps using touches of the yellow earth pastel, to suggest distant fields and boundaries.

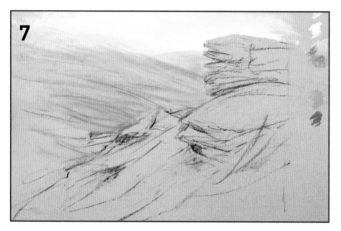

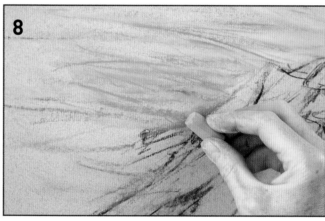

7 Using light olive green and mid olive green, begin to work further down the fields. Since this is still the midground, don't use colours that are too saturated and work the area lightly. Aim to leave a few gaps, so that the midtone surface shows through.

8 Add a hint of light blue-grey along the field edges to suggest trees; making the marks larger for areas closer to the viewer. Don't be tempted to try to draw any details, and keep your touch light. At this point, step away from the painting and wash your hands. The background is not necessarily complete, but we need the foreground in place to make sure the balance is correct.

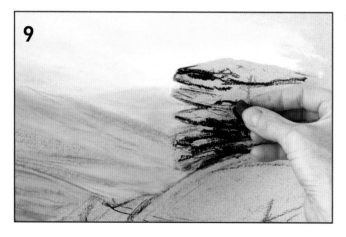

9 Even though the foreground rocks are very dark, we want to avoid using black as it will deaden the picture. Instead, use very dark blue. Use this to paint in the darkest darks, pressing hard. Use the edge of the pastel to help create the sharp, fine lines; and the side to block in areas of shadow.

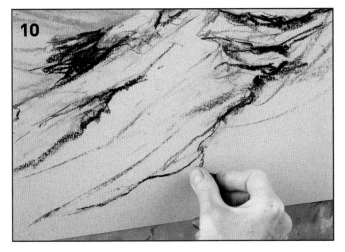

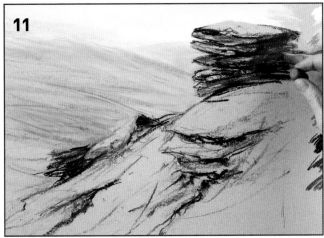

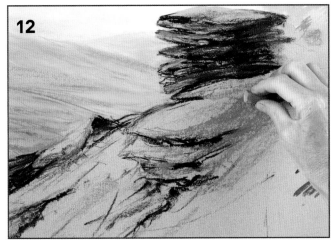

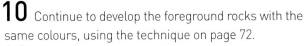

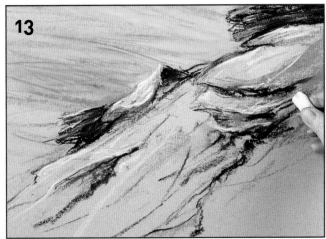

10 Continue to develop the foreground rocks with the same colours, using the technique on page 72.

11 Introduce slate grey to create a faceted appearance on the rocks.

12 Use the edge of a very dark brown pastel to warm and vary the darks with sharp details; and the side of the light blue-grey to add sweeping marks.

13 Use pale grey-lilac to pick out areas where light catches the edges of the rocks, with fine twisting lines.

14 Use the mid olive green to add soft, smudged textures to contrast with the rocks.

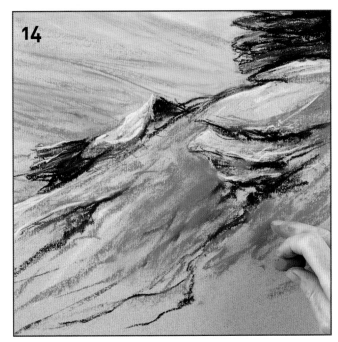

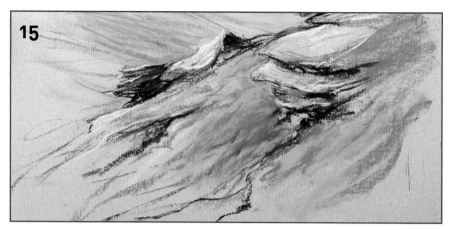

15

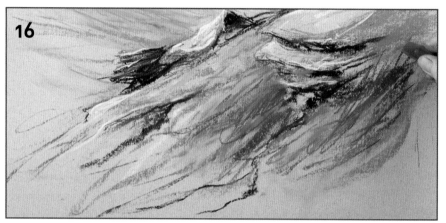

16

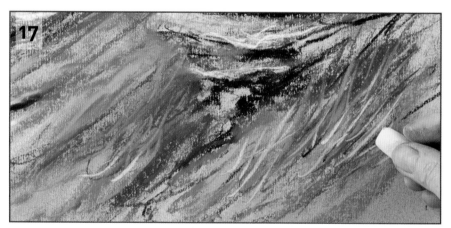

17

15 Add highlights to describe the contours of the land with the light olive green.

16 Add more impact to the foreground with dark green hatching. Both the strong tone and jagged marks help to create the contrast between the foreground and background.

17 Add some fine grasses with the other greens, a raw sienna and a pale warm yellow.

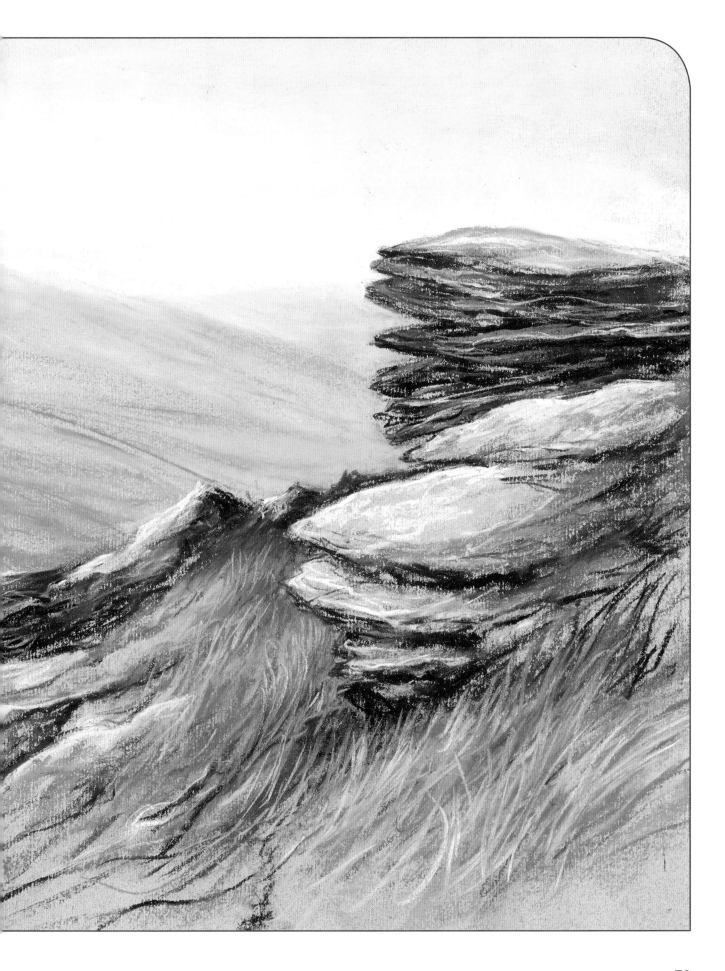

Sunlight Behind the Tor

This painting uses a rich blue surface, which is darker in tone than the demonstration on the previous pages, and has resulted in a more colourful painting. I like using darker surfaces under rocks, as it gives them a feeling of weight. By letting some of the blue surface show at the top of the sky, it feels like a sunnier day. I have also used more bright lilac, both in the rocks and the distance.

There is very little detail in this painting. To draw the eye to the focal point of the rocky tor against the bright sky, I have used strong tonal contrasts and vigorous marks rather than detail.

In this foreground detail of the rocks, you can see where I have pressed hard with my marks and where I have been very loose and sketchy. Note the loose hatching for grasses. These marks contrast with the smudged background.

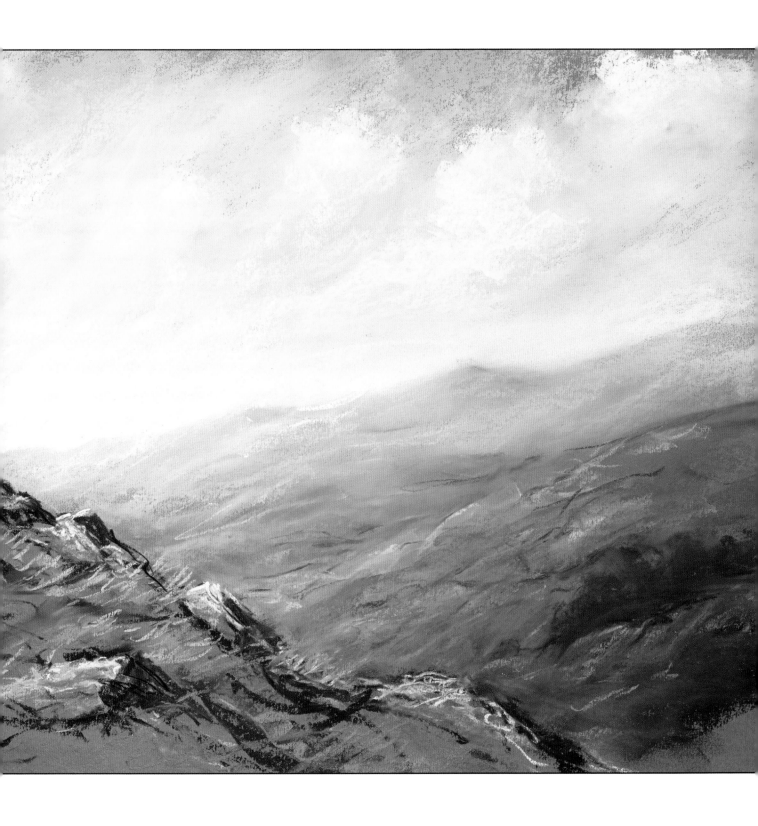

Skies

Skies are another of the subjects perfectly suited to soft pastels, as they consist of subtle changes and layers of swiftly-changing clouds.

When painting clouds, the approach I take is to think of the blue sky as a theatre backdrop, with the clouds passing in front of it like pieces of scenery. Let's look at some different examples of the sky.

Sky detail

For a really smooth sky that changes from rich saturated blue at the top to paler, more faded blue in the distance, I apply several layers of pastel, overlapping the colours. If you don't apply enough pastel here, you won't be able to cover the surface smoothly. Notice how the blue is paler and more lilac in the distance.

Cloud detail

Clouds tend to have a strongly defined side, usually where the light is hitting them, and a softer side where they are more shadowed.

The cloud base, where there is a change in temperature, means that clouds, or masses of cloud, often have a flatter edge along the bottom. You can often see these receding into the distance, and appearing to get closer and closer together.

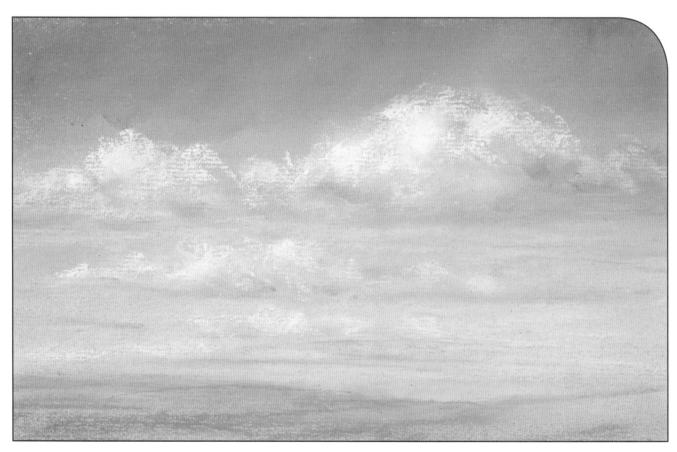

A Summer's Day

Notice how some of the colours from the land are reflected into the clouds, and some of the cloud colours appear in the landscape. This is something that happens naturally, and will give your painting harmony. Don't forget that the rules of perspective apply to clouds – they appear smaller as they go into the distance. You can often see the cloud bases receding into the distance, appearing to get closer and closer together.

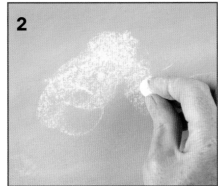

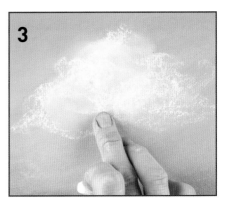

Cumulus clouds

You can build up fluffy cumulus clouds in layers over your blue sky.

Cumulus clouds are found lower down in the sky, so you tend to need a sky with a gradient – that is, one that changes gradually from rich saturated blue at the top to paler, more faded blue in the distance.

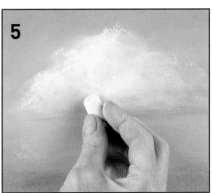

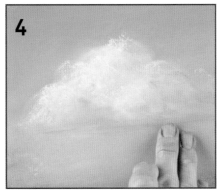

1 For a really smooth blue sky, apply several layers of pastel, overlapping the colours in order to cover the surface. You can smooth areas like this in with the heel of your hand for speed.

2 Use the side of a cream pastel to apply swirling marks.

3 Smudge the marks in, then overlay lightly with more swirling marks to develop the shape. Press harder on the side where the light is coming from.

4 Add lilac for shading, keeping it mainly near the base, and on the side of areas in shadow.

5 Add a hint of pale pink to warm the effect, and more cream for highlights. If necessary, you can refine the shape of the cloud with blue pastel, or use a scraper to remove excess pastel. However, do not soften, smudge or scrap over the highlighting marks. You need those to jump out and catch the viewer's eye, so they need to be marks that sit on the surface and are left like that.

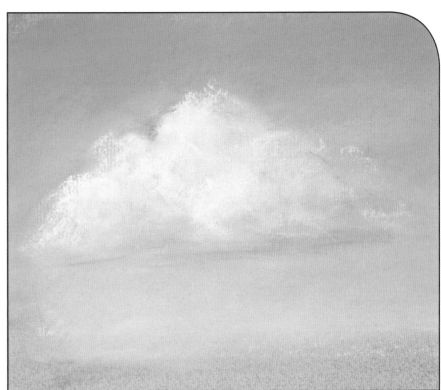

The finished effect
To create a focal point you can redefine part of the edges of your cloud, and create an even stronger contrast of light and dark. I have done that here by adding some of the richest blue sky back in against the cream highlights on the lighter side.

Cirrus clouds

Cirrus clouds appear high in the sky, light and wispy. To achieve this effect you can apply light marks of creams and lighter colours over blues and soften them more than cumulus clouds (see page 83).

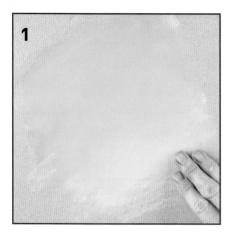

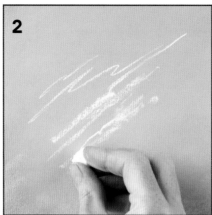

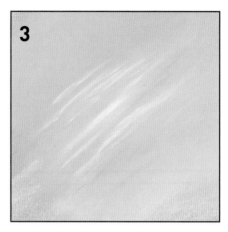

1 Apply of layers of different blues over the top of one another. Smudge them in until the texture of the paper is completely covered; this creates a nice soft surface.

2 Very lightly, apply some linear marks using cream pastel, twisting the pastel occasionally. Aim to evoke the wispy marks of the clouds.

3 Following the direction of the lines, smudge the pastel into the smooth surface.

Cirrus study

Here I have developed the wispy cirrus clouds with more pressure applied in places to make some clouds look more solid and closer than others. As a contrast to this, some clouds have been softened so much that they hardly show up against the sky.

Soft pastels really lend themselves to this type of work, and it can be really enjoyable to see your clouds emerge as you gently apply pastel and smudge it in, and build up some layers. Better quality pastels will give a more pleasing result here.

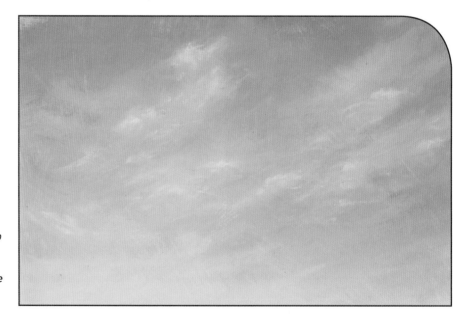

Dramatic skies

To paint stormy skies is to capture dramatic movement and energy, so I like to work bigger and stand up at my easel for this.

The cloud masses fill the sky, and you need big, strong arm movements to cover large areas.

The colours that you use will probably become darker, with more greys and purples, as well as blues.

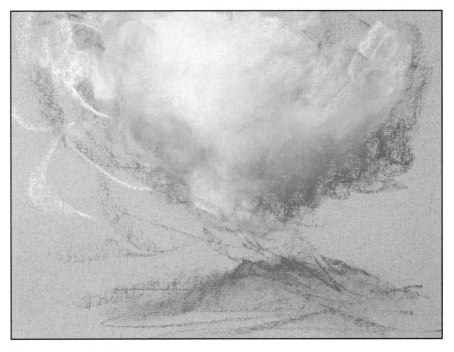

Preparatory sketch

The sky dominates this composition by taking up about two-thirds of the painting area. On a midtone surface, I used broad, energetic strokes to establish where the land would be. I then sketched in the cloud mass with strong swirling marks. Having established these two dominant areas, I left the sketch unfinished, to start on the painting. This was because I was just using the sketch as a way of understanding how I would approach the painting.

Rain over the Moor

Like the preparatory sketch, I sketched in the cloud mass and hills with broad energetic strokes, and then smudged some blue sky areas around the clouds.

I then concentrated on the shadow areas of the cloud mass, using purple and grey-blues. The sky, in strong contrast to the shadows of the clouds, is more colourful and brighter, so I used bright blues, softened and receding to lilac in the distance. There is a glow of light above the horizon, so cream is smudged in there.

I smudged vigorously as I went along, to emphasize the softness of the clouds, and stood up at my easel to get more energy into the piece.

Each layer of pastel on the clouds then got lighter than the last, with lilacs, pinks and warm creams creating highlights.

I added detail and colour to the moorland below, and smudged some of the browns and greens from the moorland into the clouds. Notice how the blue shadow colours of the clouds are also to be found in the landscape below.

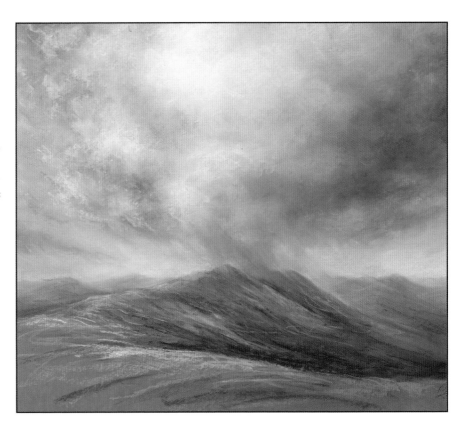

Water

You could write a whole book on how to paint water in pastels. There are hugely different approaches to capturing the light movement of a babbling brook, the still calm of a lake, or the rolling swell and crashing waves of the sea.

As usual, we can use a combination of observation and techniques. Here are a few examples of different techniques for different types of water. In each case, the direction of the mark-making describes the type of water.

Light on the water

If you are painting water that is calm and flat, you can describe this by using horizontal marks. Lay down and smudge some light blues for sky, and darker blue greens for the sea. Using a light blue green, make horizontal marks on the water. Do the same with a cream soft pastel, keeping the marks horizontal using the long edge of the pastel. Do not smudge these marks, because if you do so, you will lose the 'sparkle'.

To add to the quality of light, add some more cream into the sky above the place where you have placed the light on the sea. Add another layer to some of the central part of the light on the sea.

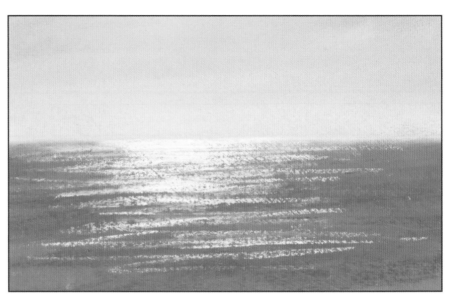

Simple light on water

To create a feeling of the light on calm water, build layers from darks to lights, using the pastel on its long edge, and dragging it along sideways, to make horizontal marks, thinking as you do so that the water is flat.

Light on water with more movement

Work as with flat water (see above), building layers from dark blues, then add lighter blue/greens, and cream or white for highlights.

To get a feeling of the light catching the gentle ripples in the water, make horizontal marks using the pastel on its long edge, but twist it slightly every now and then, like we did for the twisting technique on page 50. Slight variations in pressure will also add to the feeling of ripples and small waves.

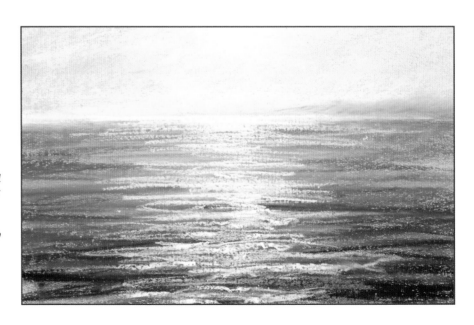

Low Tide

To show how still the water is at low tide, I have been careful to keep all of my water marks horizontal, whereas the rocks are drawn with more vigorous marks that twist and turn. The water and sky are smudged to give smoothness where needed, and mist in the distance.

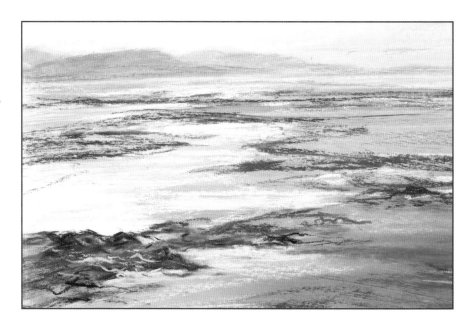

Sea Light

The focus in this sketch is the light shining, as the sun emerges from the clouds. To emphasize the light on the water, I have pressed hard with a cream pastel. For the sparkle on the water I have grazed the cream over the surface gently, and left it unsmudged. Where it picks out the texture of the surface, it creates sparkle. If I smudged that, it would deaden it completely, so it is important to leave the marks untouched. I have used peachy-pink colours to give the sketch a warm feeling of approaching sunset.

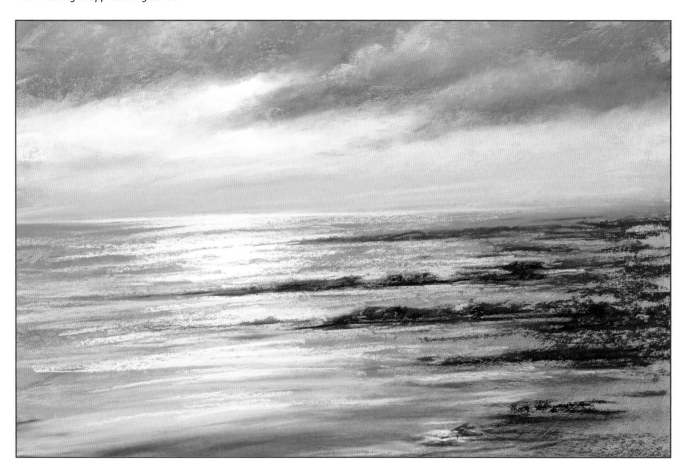

Breaking waves

I draw and paint breaking waves with a combination of smudged layers and marks that move around to capture the movement. I often start with darker layers and build lighter colours on top of them.

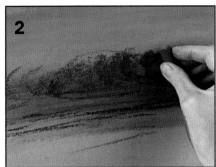

1 Even quite a choppy sea follows a horizontal pattern, so apply some dark and mid blues and blue-green colours and smudge them into horizontal bands for sea and sky.

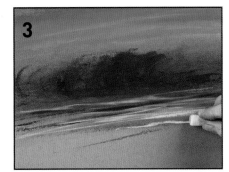

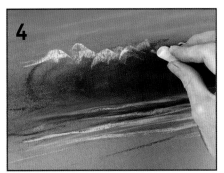

2 With a dark green, make curved marks to describe the shape of the large wave. Look at the shape of the shadows as you do this.

3 Soften this colour in, adding cream on the lighter areas of water and softening this in too. There is a deep shadow under the wave as it curls over, but in front of that the water is flatter, so it catches the light from the sky. Using a light pastel on its edge, make horizontal marks that twist and turn very slightly, to create the effect of the light catching the ripples.

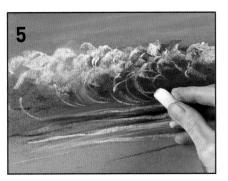

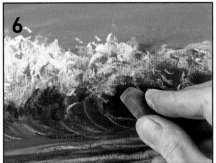

4 Smudge the cream, softening it in some places, leaving it bright in others. For the surf on top of the wave, use a cream pastel to add some light, twisting marks.

5 Continue building the marks. Imagine the wave crashing over towards you. Use some of the lighter colours to make marks that describe the direction of movement.

6 Use a darker blue-green to reinforce the depth and movement within the wave below the crest. Aim to bring out the curve of the wave.

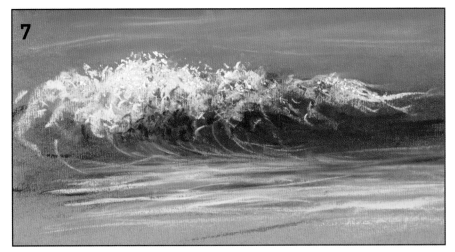

7 Add tiny dots of pure white pastel as loose spray, then add some hints of the beach into the lower part of the image, using horizontal strokes of a sandy-coloured pastel.

Spray

Another way to create the effect of spray is to lay your paper flat and use a scalpel to scrape white pastel onto the surface. The tiny pieces of pastel help to make a very fine spray effect.

The technique is shown here – draw the scalpel blade across the pastel to scatter tiny fragments.

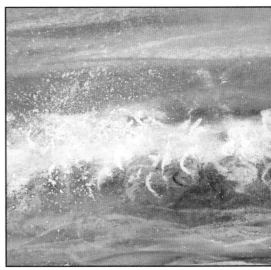

The effect is shown here on top of a wave made using the technique on the facing page.

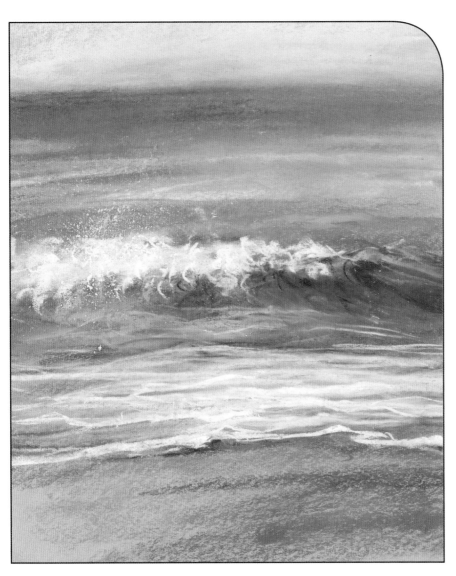

On The Shore

This painting uses the breaking waves technique detailed opposite, but has been developed further, to include more of the sea above and below the wave. I have varied and twisted my marks on the surf, and softened them in some places. I have brought the colours of the beach into the waves. Notice how the area of the sea above the crashing wave is smudged to make a contrast to the wave itself.

Calm water and reflections

If you want to create the effect of calm, still water, put on two or three layers of pastel, and smudge them in a horizontal direction.

The golden rule with reflections is that they must be vertically below the object that they are reflecting. Remember that light and shade reflect as well as solid objects. It is usually the reflected light that will give your painting some magic.

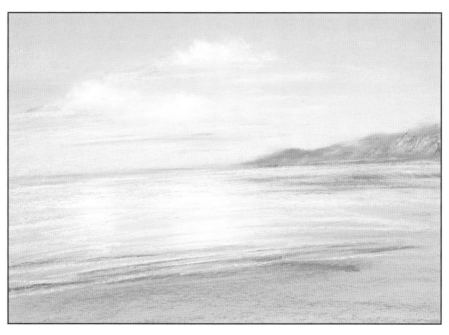

Clouds reflected in calm sea

The light reflections in the water are directly below the clouds. The calm of the sea is emphasized by smudging it smooth before adding the reflections. To maintain this calm, all reflection marks are made horizontally.

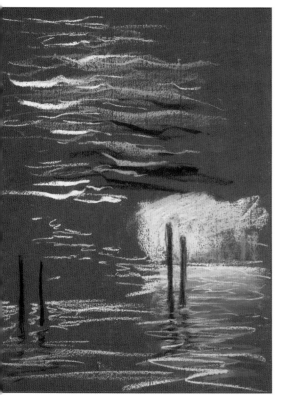

Sketches of reflections

It is always good to practise before producing a painting. This is a little sketchbook page of experiments with colours and capturing the light on ripples of water.

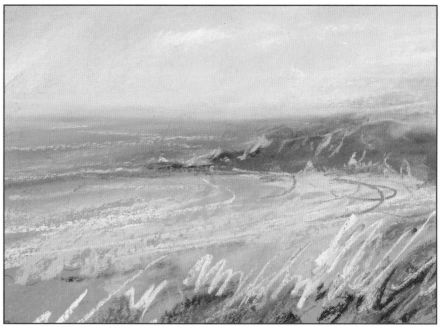

View of the Bay

This is a very quick sketch to get a feeling of the wide expanse of a bay. I chose to work on a light terracotta surface to give a complementary zing underneath the bright blues. You will see in the Life in your paintings section (see pages 110–139) that this colour works well under the flesh tones of figures and portraits. Because of this, I use it a lot with beach scenes.

Swirling water

Quick sketches from life such as these – made while sitting next to a stream watching the water rush and swirl around the stones – are not masterpieces to frame. They are, however, worth their weight in gold as an information-collecting exercise, and I would highly recommend getting out and sketching from life if you can. Even if you never look at them again, the act of sitting, looking intently and drawing from life will have taught you more about your subject than you realize, and you will use that information when you next draw something similar from a photograph.

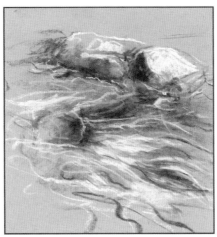

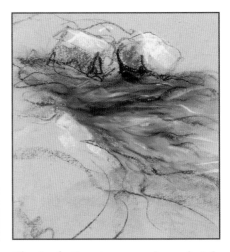

Ripples in the stream: mark making

These are just light marks made with charcoal to try to capture the energy and movement.

Ripples in the stream: tonal sketch

With this one I used charcoal and some cream and white pastel to show the swirl of the water round the rocks, observing lights and darks. I smudged some of the water, and then sketched light marks on top. I pressed harder on the rocks to make them feel heavier.

Ripples in the stream: colour sketch

I applied the same principles but using colour, looking at another part of the stream. Again, smudging layers for the water, stronger marks for the rocks.

Billowing Clouds

In this exercise we are looking at painting billowing clouds over an estuary; how to create a sense of distance and atmosphere with water and sky. We will be building layers and using smudging techniques for the sky, and painting the estuary and beach with simple horizontal strokes. For the tiny figures, we will use pastel pencils.

You will need:

Canson paper: Ivory
Willow charcoal
Pastels: Bright blue, mid-blue, turquoise, pale lilac-grey, light grey blue, mid grey-blue, dark lilac-grey, shadow grey, warm light grey, pale creamy-white, peach, warm brown and dark brown
Pastel pencils: dark brown and red ochre
Scraper

Source photograph

Colour palette

Unison blue green 3, blue violet 9, blue green 10, add 32, grey 33, grey 34, grey 8, add 42, grey 27, brown earth 14, brown earth 29, add 39 and blue violet 8. The additional two swatches are the pastel pencils (see 'You will need' above).

1 For a fresh, clean sky, I don't like to use charcoal, as this can dirty the result. Instead, you can use one of the sky colours (such as bright blue) to block in the initial shapes. Sketch lightly, and establish the shadow under the clouds; this helps to give them some structure. Use a ruler for the horizon, and leave space beneath it for the sea area.

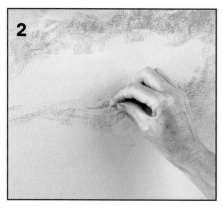

2 Use the side of a bright blue pastel to cover the upper part of the sky, avoiding the clouds. Don't worry if you accidentally work over the edge of a cloud – pastels are forgiving; you can fix it later.

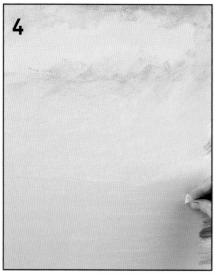

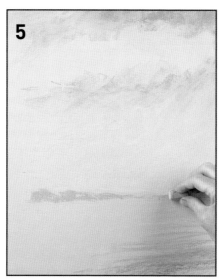

3 Apply a lighter mid-blue with broad, bold strokes, mainly around the middle of the sky. Use swooping marks in the sky, and horizontal marks in the sea.

4 Change to a turquoise pastel and fill in the remaining area of the sky at the bottom, plus touches in the sea. Lightly overlay a pale lilac-grey to soften and mute the blues in the sky, particularly near the bottom. Do the same in the sea, adding more horizontal marks.

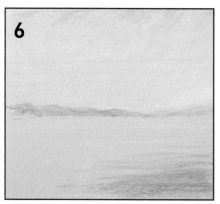

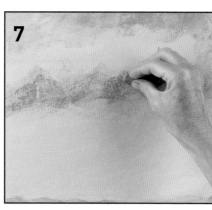

5 Add more weight to the sea with the two grey-blue pastels, then use the same colours to add in the hills in the distance.

6 Overlay the hills in the distance with dark lilac-grey, then do the same in places with pale lilac-grey. Add more pale lilac-grey to the hills on the right-hand side so that they appear further away.

7 Use a shadow grey to paint in the cloud base. Follow the direction of the cloud, and use swirling, twisting marks.

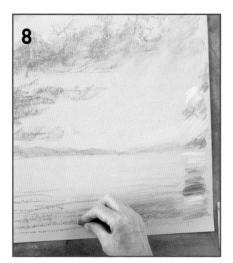

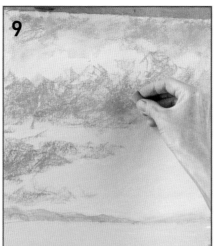

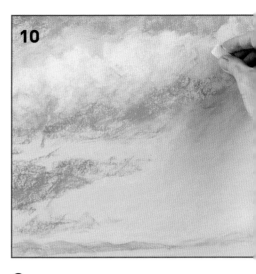

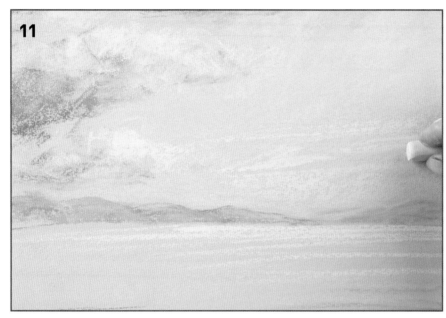

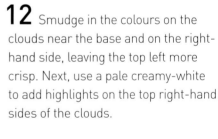

8 Use the same shadow grey in the sea, right at the bottom of the picture.

9 Using the dark lilac-grey, build up the cloud shadow, working up over the centre of the clouds.

10 Use a scraper to remove excess pastel from the whole painting, then use a warm, light grey pastel to start to add the sunlit areas of cloud. Press quite hard, and use rounded but vigorous back-and-forth movements.

11 Add some fine lines of the same colour on the sea near the horizon, and use the tip to add some wispier clouds in the distance.

12 Smudge in the colours on the clouds near the base and on the right-hand side, leaving the top left more crisp. Next, use a pale creamy-white to add highlights on the top right-hand sides of the clouds.

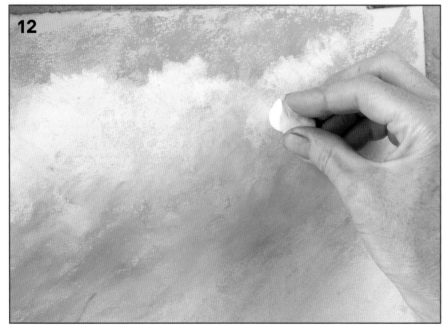

13 Continue to build the highlights on the tops of the clouds, using short, wandering marks and the side of the pale creamy-white pastel.

14 Use a peach pastel to paint in the beach with light horizontal strokes, then add some subtle touches of the same peach into the cloud.

15 Use a warm brown to hint at the beach in the foreground.

16 Work the edge of the dark brown over the beach, working into the sea.

17 Add a little of the same dark brown into the base of the hills on the left-hand side, then add a few linear strokes of the edge of the pale creamy-white pastel near the horizon.

18 Still using the pale creamy-white, refine the sea area with linear marks, smudging them slightly with very short up-and-down marks.

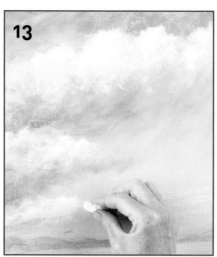

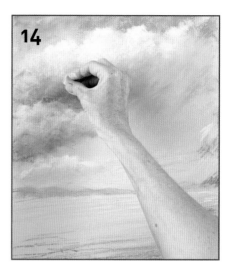

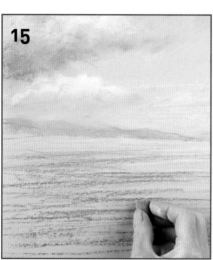

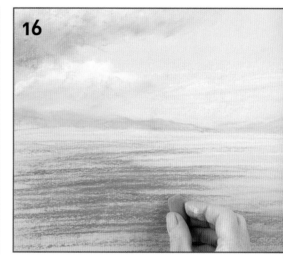

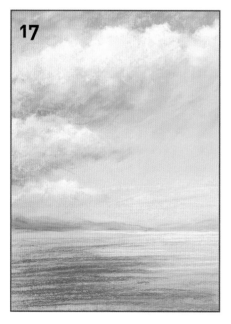

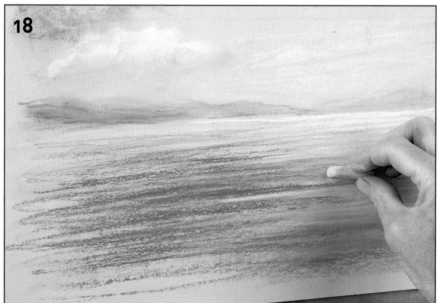

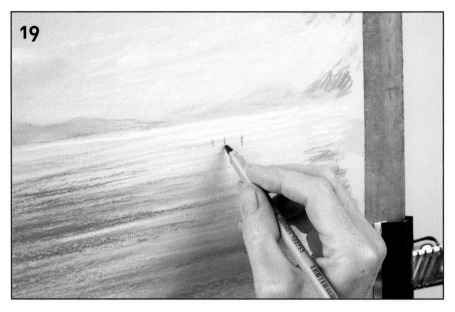

19 Use a very dark brown pastel pencil to add a few distant figures – these should be very simple; almost like upright tadpoles.

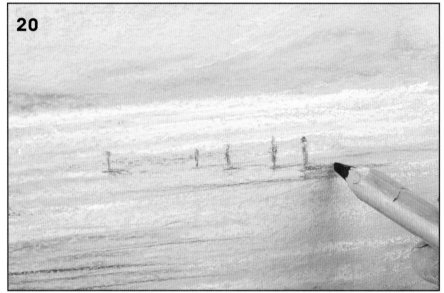

20 Still using the dark brown pastel pencil, add a short shadow to each figure.

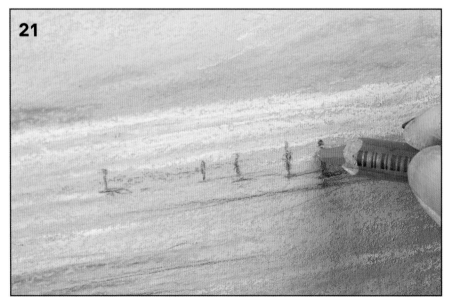

21 Use the red ochre pastel pencil to add a tiny hot spot on one of the figures. This add a little eye-catching contrast.

Opposite:
The finished painting

To finish, I added some reflections under the figures with pastel pencil. I also added some light on the water and softened the distant cloud to knock it back into the distance. These little touches can add depth and atmosphere to your work.

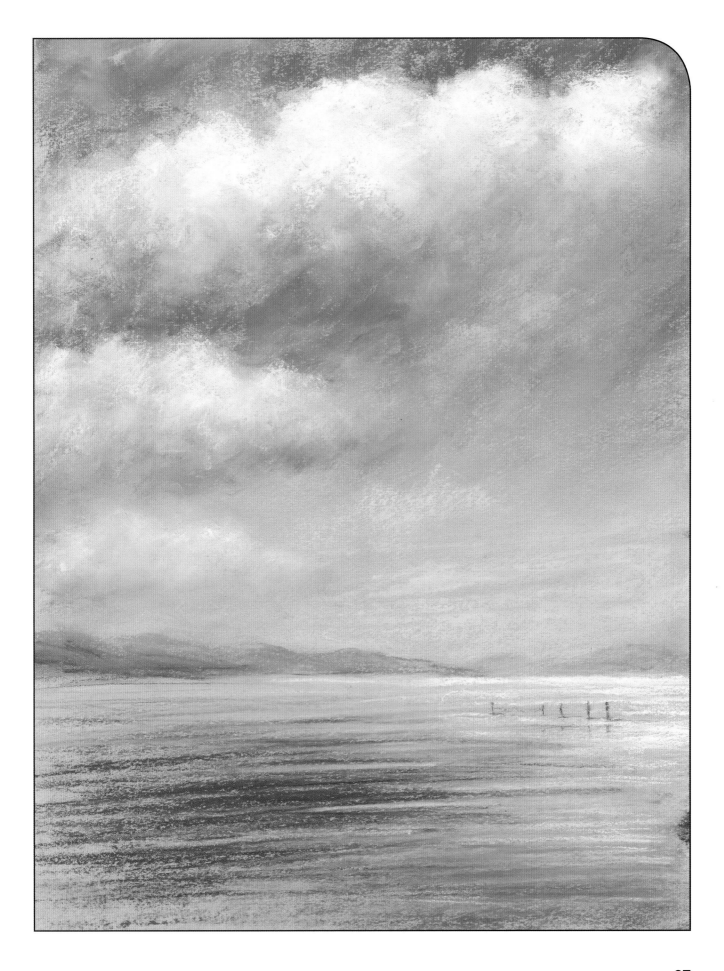

Trees

Trees vary according to their type, their age and the season of the year. They also require different handling depending on whether they are close to us or seen in the distance.

Mark making and pressure

Let's look at how we apply our marks for some different trees. Rather than thinking of trees in terms of their species, I think of the shape and character of each tree individually. Is it tall and slender, or strong and wide? A young sapling, or twisted, old and gnarled?

Young saplings with graceful smooth trunks and long branches can be conveyed with sweeping linear marks, made using the long edge of the pastel. The heavy texture and form of an old oak tree would be better suited to heavier, vigorous marks that twist and turn.

Think about the pressure that you apply. Whether you use the pastel on its edge or on its end, you can press harder to get a thicker line where you want to have more weight, such as on the trunk, and lower down, nearer the ground. As you get further up the branches, you can press more gently, to convey the thin twigs.

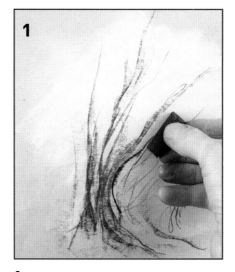

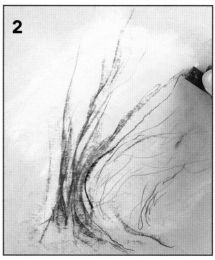

1 Start by smudging a background of soft pastel on the paper, to create a smoother surface to work on. Next, use the pastel on its long edge, and the twisting technique (see page 50) to draw the lines of the trunk and branches. Press hard at the base, and then reduce the pressure as you move up the branches, to create thinner marks.

2 For the ends of the branches, use the sharp end of the pastel, to get finer marks.

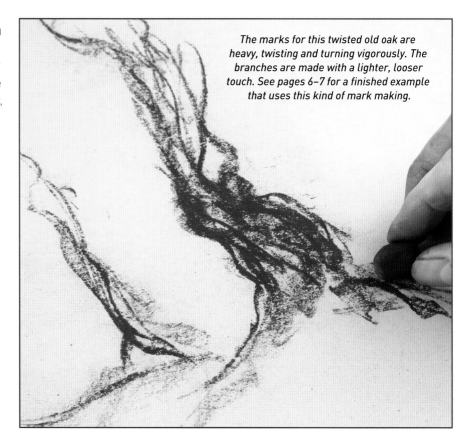

The marks for this twisted old oak are heavy, twisting and turning vigorously. The branches are made with a lighter, looser touch. See pages 6–7 for a finished example that uses this kind of mark making.

Twisted branches in the distance

Trees in the distance appear to have very fine branches, which can be difficult to draw with a chunky soft pastel. This is where I use my Conté crayons or harder pastels, both of which give me a sharper mark. For very fine branches I might use a pastel pencil.

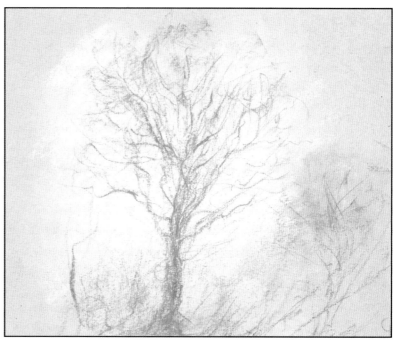

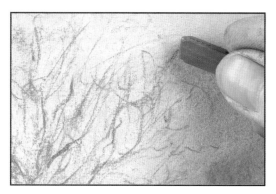

Use a Conté crayon to create the finer branches of trees in the distance. Here I have smudged an under-layer of pale sky blue so that I have a smooth surface to work over.

Misty Woodland

With this piece I enjoyed experimenting with ochres and lilacs to conjure the feeling of an early, misty morning in the woods. I used my pastels on their edges with twisting marks for the slender beech trees, using more pressure when drawing the trees in the foreground. I used shadows to create the path leading us through the painting.

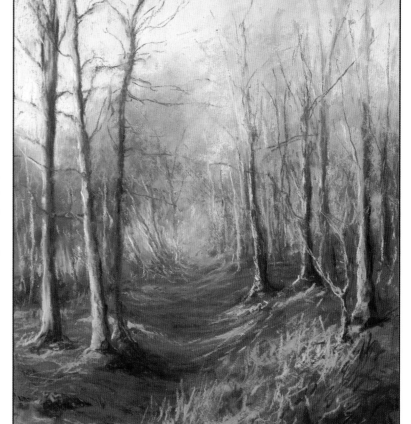

Leaves and foliage

A simple and effective technique when painting leaves is to make little marks with your darker greens first, and then build layers of lighter greens, yellows, oranges and reds if it is autumn. Rather than trying to paint each individual leaf, think of them in areas, making patterns. You will see lighter and darker areas in the canopy of leaves above you.

Pine needles

To get the effect of clusters of pine needles, you can make little scooping marks, building up in layers from dark blues to light greens. The group of firs on page 102 shows an example of this technique.

1 Use the dark blue pastel to make a mass of very short curving marks.

2 Repeat the process with a dark green pastel, creating clumps within the mass and leaving some areas of shadow.

3 Add some sunlit highlights in the same way, using a bright green.

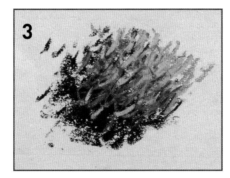

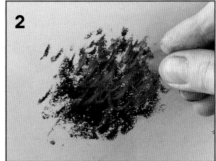
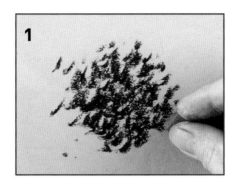

Deciduous leaves

A variation on this technique can be used for other leaves. Using larger marks will create the effect of deciduous tree foliage.

Opposite
Silver Birch

This painting is similar to the demonstration painting The Birches *(the finished painting is on page 109). However, it is painted onto a blue-grey surface rather than a mid-brown one. Because I have covered most of the blue-grey, the paintings are very similar, but this one took longer to produce as I used more brown pastels, and more layers. Neither picture is right or wrong – they are simply different versions of the same thing. It is a useful exercise to do similar paintings on different colours of surface. Can you see the differences between these two?*

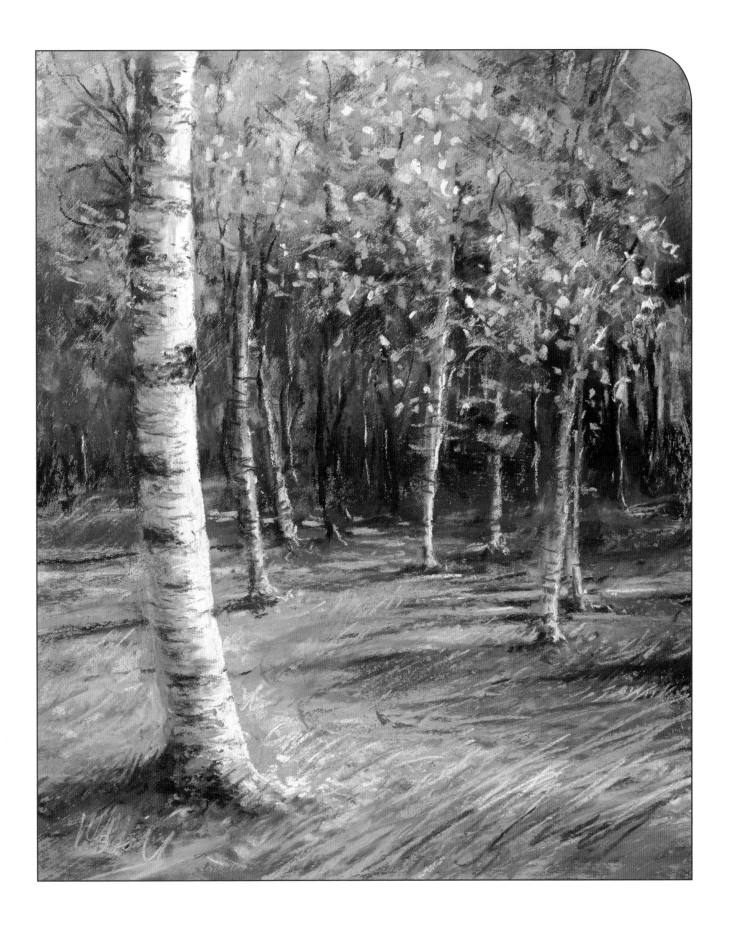

Groups of trees

As with any drawing challenge, I simplify the initial shape as much as I can. If I am drawing several trees together, I look first at the shape of the whole group, before picking out details of individual trees. It helps to think of a group or row of trees as just one overall shape to start with. You can pick out details later, but even then you will find that often the trees grow together, forming a canopy.

Negative space

In order to help make sense of a complex mass of trees, try looking for the negative space: the gaps between and within the objects. In the example below, notice that some of the spaces between the trunks of the trees are wider than others, and that there are gaps in the mass of foliage.

Looking at the space around and between your subjects is a great way to get shapes and proportions right.

Sketch of a group of firs

The inset shows the negative space in pink.

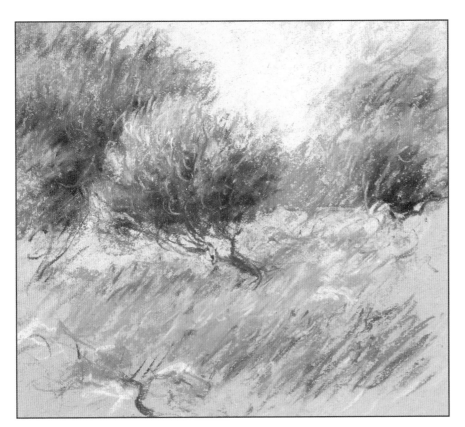

Mark-making techniques

The marks you make will help to convey the nature of the trees.

Olive Grove

Olive trees have twisted trunks and branches, and these were growing in amongst the scattered stones of ruined buildings. To capture their character, I used strong twisting marks for the trunks and lighter ones for branches, and little curved flicks of my pastels for the leaves.

Dappled Sunlight

These slender silver birches were growing in long grass, with patches of sunlight filtering through the canopy of leaves. To get the feeling of dappled sunlight, I used lots of light, flicked marks, and the hatching technique for the grasses, which not only described the shape of the grass but was a way of combing lots of colours to depict the dappled and changing sunlight. Remember, that less is more: we don't need to put in a lot of detail.

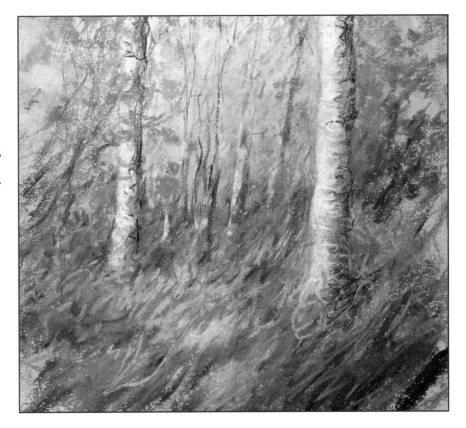

The Birches

This picture is all about the bright, light birch trunks and yellow leaves against the darker background. Here we are using mountcard primed with a mix of two **Art Spectrum Colourfix** primers (see page 11). This more textured surface is ideal for building layers of lights over darks, and building the tree bark texture in this painting. For this example, I mixed together the two primer colours, but any mid-to-dark colour would work for this exercise.

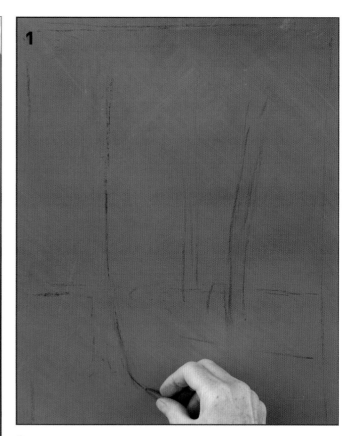

1 Use charcoal very lightly to sketch in the basic shapes of the horizon and the main birches.

You will need:

Mountcard
Primers: Burgundy and sand
Pastels: Dark green, dark blue, light blue, golden yellow, light yellow, orange, brown, mid-green, off-white, blue-grey, light green and neutral brown
Conté crayon: Black
Willow charcoal

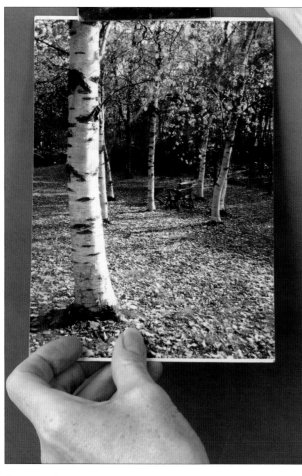

Source photograph

I am starting on quite a dark background, to help create those darks without having to use too much pastel. Remember; this surface colour will be an important part of my palette.

Colour palette

Unison pastels: dark 8, dark 18, blue green 6, grey 20, red earth 9, green 15, add 42, grey 8, add 39, add 9, and yellow green earth 9. The additional swatch is the Conté crayon (see 'You will need' above).

2 Use the side of the dark green pastel to add in the shadowy depths of the woodland down to the horizon. You can work right over the main birch trees.

3 Increase the depth of shadow lower down in the area using a dark blue pastel.

4 Add some light blues for the bright sky, and sketch some autumnal yellows, oranges and browns on the ground, along with a little dark green – use more horizontal marks on the ground. Be loose and light with all of marks at this stage; it is a first stage that will later be covered.

5 Start to develop these early layers using mid-green with horizontal strokes for highlights on the ground and looser marks for sunlight within the trees.

6 Gently smudge the background foliage to knock it back into the distance a little. If necessary, use a scraper to take some of the excess pastel off the surface.

7 Over the refreshed surface, I can add a base layer for the largest birch trunk using the side of an off-white soft pastel.

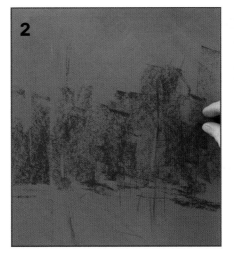

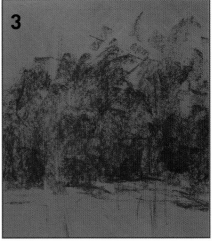

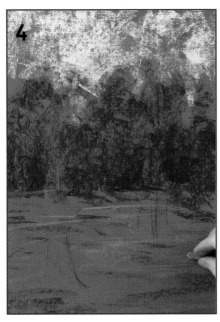

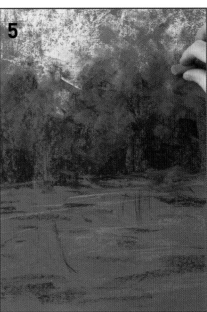

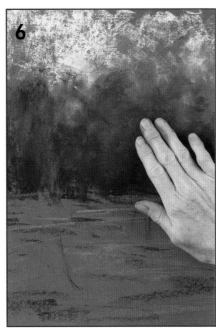

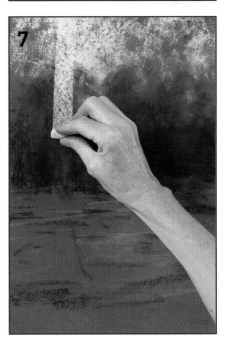

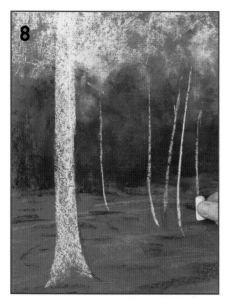

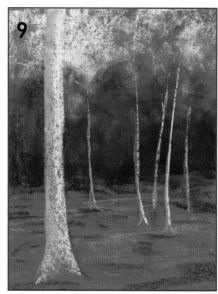

8 Use linear marks with the off-white pastel for the midground trees.

9 To make the trunks look round, add blue-grey down the left-hand side of each tree. You can be quite bold for the main tree, but use more broken lines for the midground trees.

10 Develop the foreground tree using the end of the off-white pastel. Add small textural marks and aim to suggest roundness.

11 Start to build up the foliage in the midground using the mid-green with small tapping marks. Work right up to the main tree, but not over the trunk – this will suggest the foliage is behind it. Add some foreground grasses with dashed marks, using the same colour.

12 Continue to build up the grasses and foliage with light green. Remember, nature is rarely neat; there are naturally more dense and more sparse areas of foliage. Avoid creating an even layer; leave gaps and make denser areas of marks.

13 Finish the leaves and grasses with further autumnal colours, using the yellows and oranges used earlier.

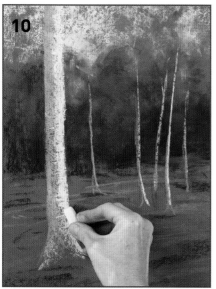

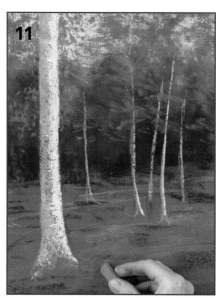

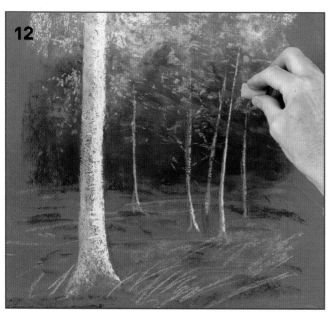

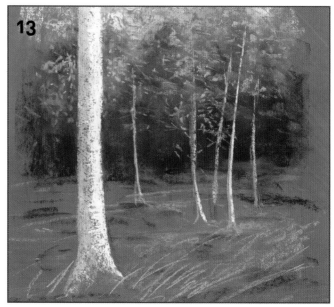

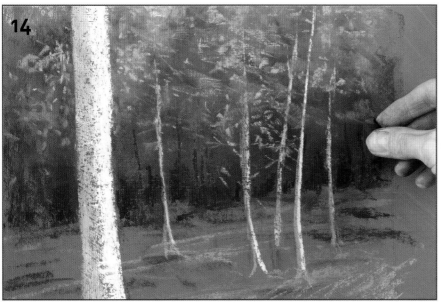

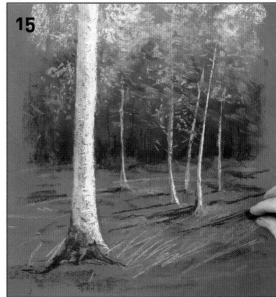

14 Strengthen the dark blue shadows under the trees. Use the edge of the pastel to suggest some distant trees in shadow.

15 Use the same pastel to add shadows cast by the trees. The midground tree shadows are simply lines, wavering slightly to suggest the texture of the woodland floor, while the foreground tree casts a larger, more developed shadow.

Tip

It is a good idea to also add some shadows coming from trees out of the image – this helps to suggest that the picture is part of a broader setting. Make sure all the shadows go in the same direction, to the lower left (i.e. away from the source of light).

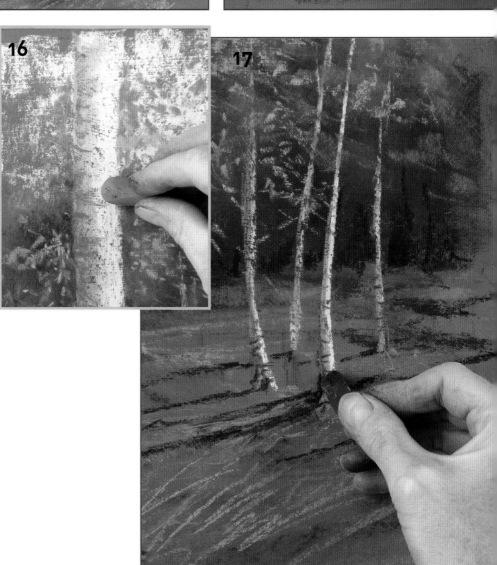

16 Use a neutral brown pastel to add some short marks on the main trunk. Make your marks curve to suggest the roundness of the trunk.

17 Enjoy developing the texture on the foreground and midground trees using tiny marks of dark blue pastel.

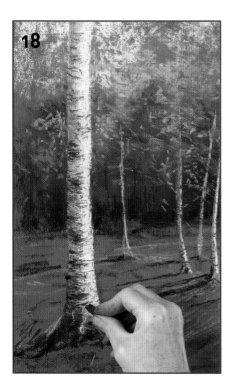

18 Use black Conté crayon to increase the contrast and tone in the foreground tree. Try to imagine the texture of birch bark to help guide your touches. Black can deaden your paintings, so use it only for tiny marks.

19 Use the strong golden yellow pastel to add some sunlit touches to both the foliage and the foreground grasses. Reinforce the direction of the light in the foreground by using the yellow only on the right-hand side of the main tree's base.

20 Add some final highlights using the off-white pastel in the same areas.

21 Hint at a path through the woodland using the lighter-toned pastels to finish.

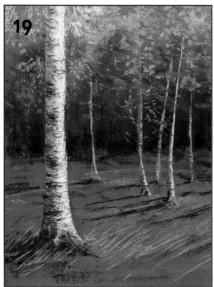

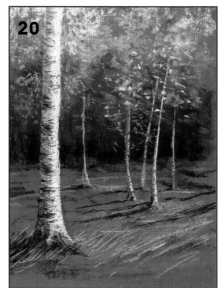

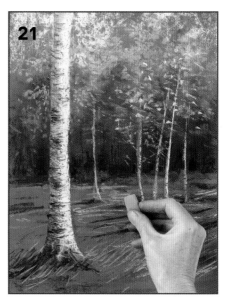

Opposite:
The finished painting

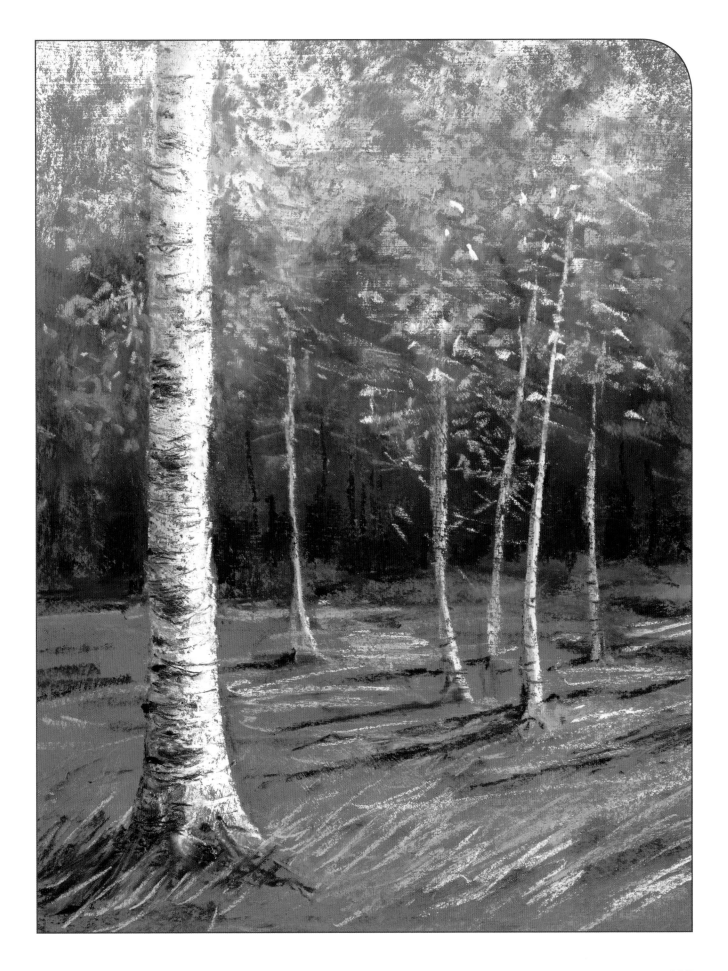

Life in your paintings

Soft pastels are great for drawing and painting figures, portraits and animals. There are no sharp edges on people and animals, so the soft quality of pastels means that you can suggest curves and subtle changes of tone and hue. You can also work quickly to capture movement.

In this section we are going to look at the importance of having a little understanding of the structure of people and animals, and how we can improve our pastel work by sketching to get to know our subjects. We can then draw and paint with more freedom and get some life and energy into our work.

Shoes and Tattoos

I love to paint people who work with horses, like this farrier. In this painting I wanted to show the strength of the horse and man as well as the heat of the day. I have done so by using strong colours and tonal contrasts. Lines of flow in the composition (see page 141) lead our eye to the farrier's hands. The background is soft and indistinct to emphasize the focus: the calm horse and the skilled work of the man.

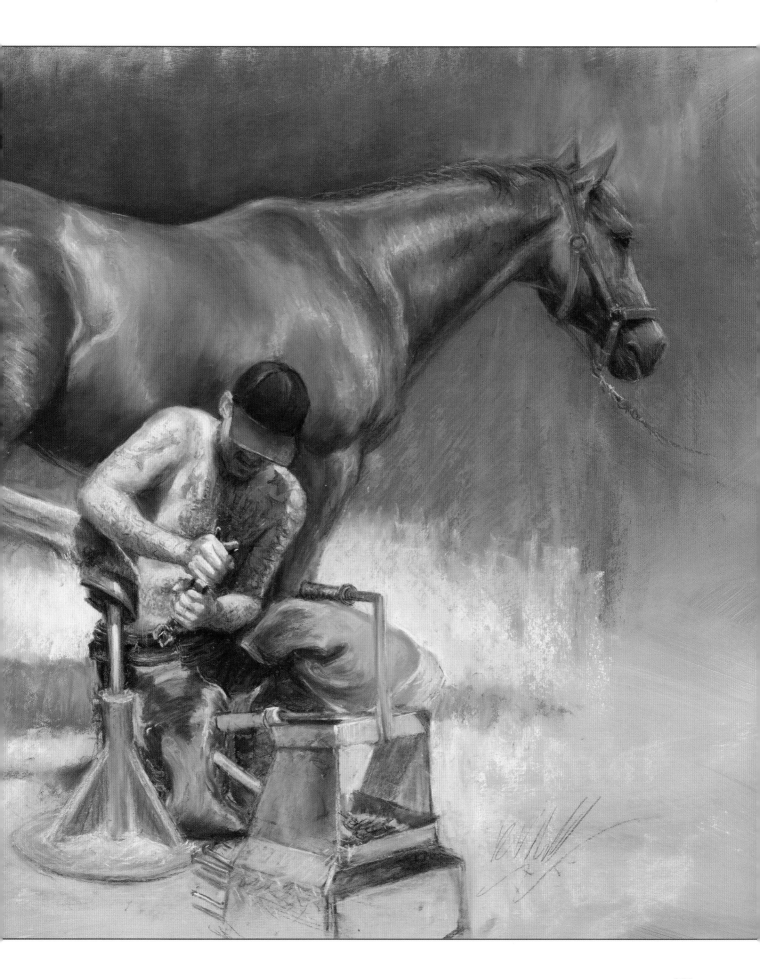

Figures

If you have a simple understanding of the underlying structure of the human body – the skeleton and musculature – it will strengthen all of your work. When we are using photographs as reference, often we run into problems when we cannot quite see the information we need. If we have some structural knowledge to fill this gap, there won't be a problem.

An easy way to understand this structure is to use stick figures, as shown to the right.

Proportions

We don't need to worry about complicated maths when learning about proportions of the figure. Instead, concentrate on the fact that the pelvis is usually about halfway down the body, and is where the figure bends in the middle.

When we are drawing figures with bent legs, it is worth noting that the femur (thigh bone) is the longest bone in the body. If you have sketched a figure and it doesn't look quite right, check the length of its legs in relation to its body.

Size of the head

The size of the head in relation to the body varies with age and person. A toddler could be a 1 in 4 ratio, a tall slender adult 1 in 7.

Curve of the spine

The spine can bend backwards and forwards, but can also twist from side to side. When I am drawing a figure the first thing that I look for is the curve of the spine, followed by the angle of the head.

The curve of the spine is never a continuous arc; it will be a series of straight lines.

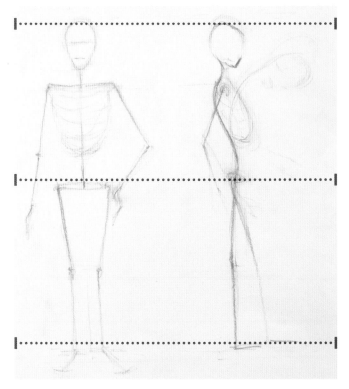

These stick figures are simplified versions of the skeleton, face-on and in profile.

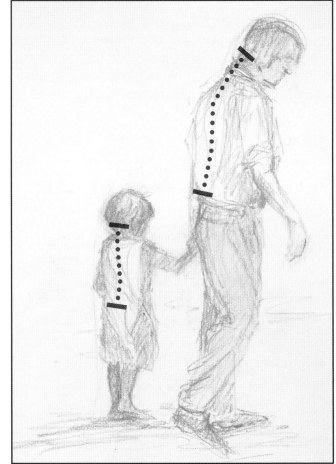

Adult and child

This simple sketch shows the relative sizes of the heads of an adult and a child. The spine is highlighted, too.

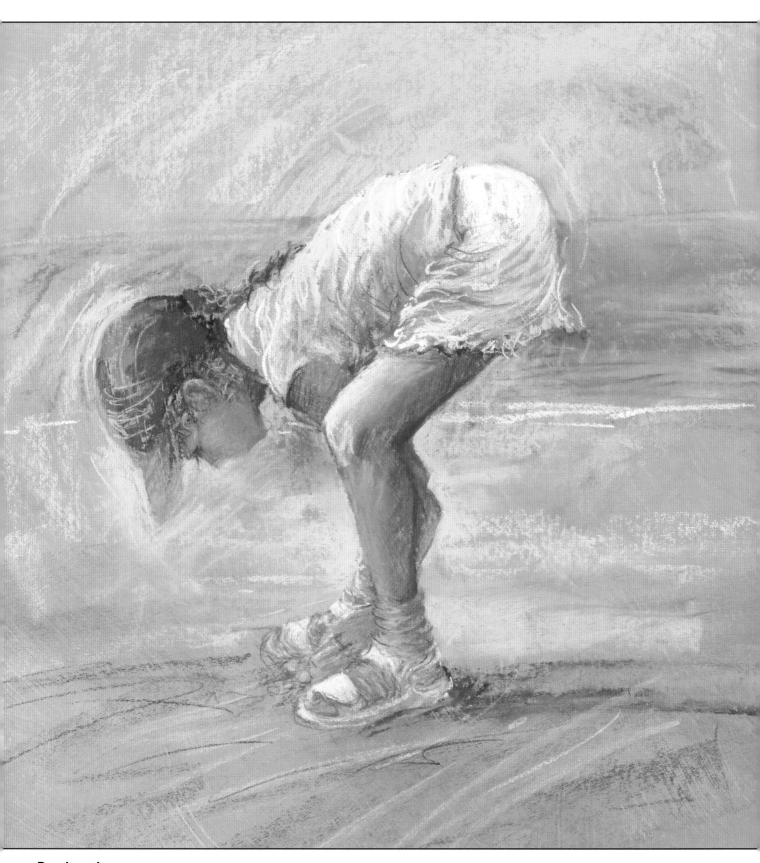

Beachcomber

*As children grow older, their heads become smaller in relation to
their bodies, but their limbs become proportionally longer.*

Thumbnail sketches and the curve of the spine

Why sketch? It helps familiarize you with the figure in front of you, and helps you get to know your subject. This is particularly important with figures. We start with the head, because this is a natural focus that tells the story.

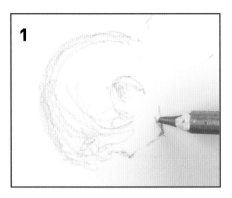

1

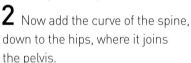

2

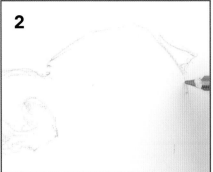

3

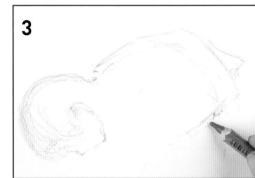

4

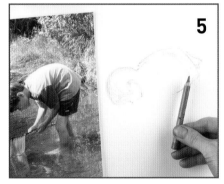

5

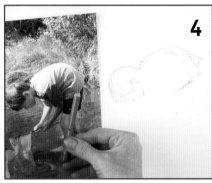

6

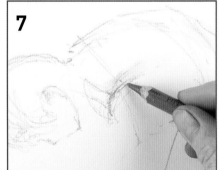

7

1 The most important parts of a figure sketch are the angle of the head and the curve of the spine. Using a red pastel pencil, draw in the head. Look for the curve of the head and the position of the ear. The ear will tell you the direction the head is facing. With these landmarks in place, you will find drawing the rest of the head (and features, if visible) much easier.

2 Now add the curve of the spine, down to the hips, where it joins the pelvis.

3 Draw in the hip lightly, to establish the position.

4 To draw the legs, hold up the source photograph near your sketch and align the pencil with one of the upper legs in the photograph.

5 Keeping the angle of the pencil constant, take it over to the sketch, near the hip marks. This is the angle of the upper leg.

6 Add a line for the upper leg, then repeat the process for the lower leg.

7 Establish the position of the shoulders in the same way as for the hips.

8

8 You can now add the other limbs using the steps above. Note that the trailing leg is partially hidden behind the first leg; you need only draw a line for the lower leg.

9

9 Using the lines to guide you, fill out the figure and add details like clothing and 'props' – like the fishing rod here.

The finished sketch

Continue to refer to the photograph as you develop the sketch further. Don't be afraid of erasing things – or even starting over – this is the whole point of sketching; to make yourself familiar with the subject. The more time you spend with the sketch, the easier you will find your painting.

Tip

Things that the figure is holding are useful both to tell a story, and also when sketching; they act a little like scaffolding for your sketch; providing useful simple shapes that are easier to draw than figures.

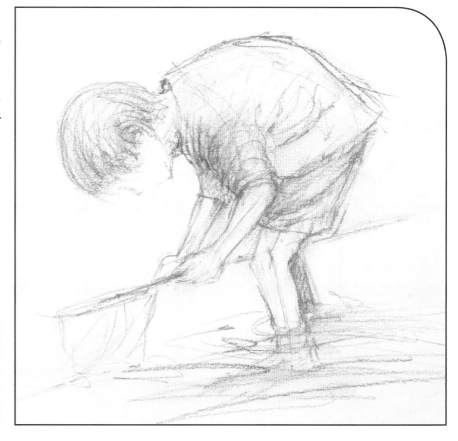

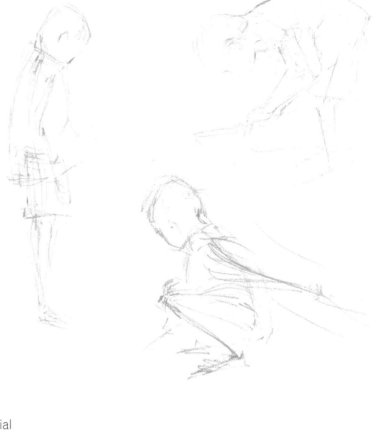

Making your stick figures look real

If you practise drawing little stick people in different positions – whether using photographs or by looking at people in front of you – you will quickly develop a way of getting a pose on the paper with a few lines.

These are a few thumbnail sketches, using pastel pencil, that have captured first the essential curve of the spine, then the angles of the limbs, and the direction the head is looking in.

From sketch to painting

Building up these thumbnail sketches into paintings allows us to combine our drawing and painting skills. For this example red pastel pencil has been used for the initial sketch on this terracotta background (Conté crayon would also work well).

Soft pastel can be used to fill out the form of the figure, and give roundness to the limbs and body. Let the red sketch show through in places, as the early sketch is still part of the whole piece.

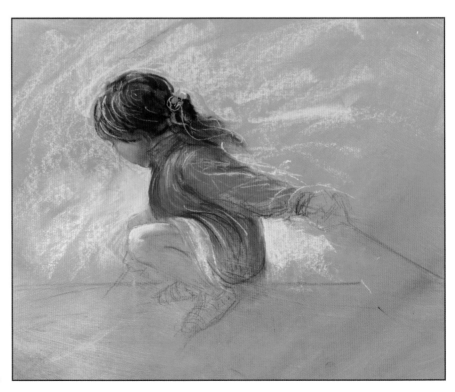

This preparatory pastel sketch shows how the three-dimensional pastel figure is built up over the stick person framework. The finished artwork is shown opposite.

Telling a story

A successful painting tells a story to which the viewer can relate. The position and the body language of figures can tell us what is happening and what they are feeling. We can also tell a lot about someone's personality and mood from their body language, without having to see their face.

Look carefully at your subjects. Are they upright and confident, with their feet placed firmly on the ground? Perhaps they are moving, or twisting to look at something. Ask yourself some questions to help you evaluate their posture: Is their weight on both feet? Where is their head in relation to their feet? Which way are they looking? Are they active and full of purpose, or relaxed and day dreaming? Does their pose reflect their personality? Their body language will help to tell the story.

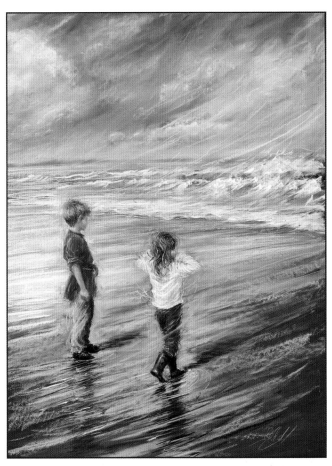

Too Loud!

In this painting the little girl is overwhelmed by the noise of the crashing waves, but her brother looks on calmly. Lines have been added around her figure to indicate movement.

Two Spades

Notice how active the sister is, while her little brother looks on. She has both of the spades; does he want one too?

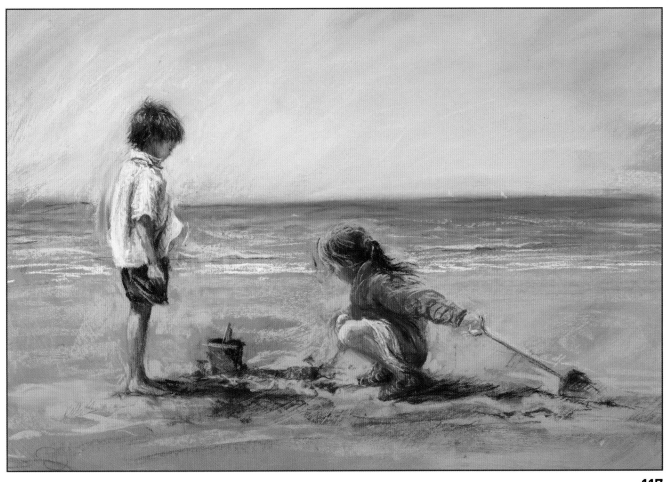

Figures in the landscape

When composing a landscape with figures, we have to be aware of the scale of the figures – that is, how big they are in relation to their surroundings. We also need to choose carefully where to place them within the scene.

As it can be tricky to get fine detail with pastels, I simplify figures in the landscape as much as possible, often just using a few lines to indicate their legs, and just a smudge for their faces.

Figures in the landscape are not portraits that need detail. They can help the viewer to connect with the scene. If you treat them as abstract shapes drawn in the style of the rest of the painting, they will become a harmonious part of the whole piece. Providing too much detail will make them become specific people, and the viewer will lose that connection of imagining themselves there instead. Even drawn simply, figures can tell a story or create life in the scene.

A Walk on the Beach

These small people have been indicated with a few strokes of soft pastel, with very little detail. Notice how the shadows serve to ground the figures. The shadows also help to tell us that the beach is flat.

Strolling Through Barcelona

Perspective matters in street scenes, both of the buildings and also the figures. In this sketch you can see where I have sketched in fine working lines of perspective, and also the horizontal eyeline.

All of the figures' heads are on this eyeline, and it is the size of each figure that tells us how close they are to us. The shadows come towards us to emphasize the beautiful sunlight coming through the gap in the buildings.

The Great Outdoors

This painting is all about scale. To emphasize the huge rocks and breathtaking scenery, I have made the climber tiny.

Gone Fishing

The figure is sketched in with pastel pencil, as this painting is quite small, and some precision is needed. The surface I suggest is a sandy terracotta colour – a warm colour that will be sympathetic under skin tones, and a great contrast to the blues we will be using. At this point I am thinking about what I really like about my photographic reference, which is the contrast of bright light and darker background. I also love Yasmin's quiet contemplation.

You will need:

Winsor paper: Terracotta

Pastels: Light blue, light blue-grey, dark turquoise, mid turquoise, light turquoise, cream, sandy, dark blue, dark pink, lilac and dark lilac

Pastel pencils: Mid-brown, white, dark blue and red

Conté crayons: Raw sienna and burnt sienna

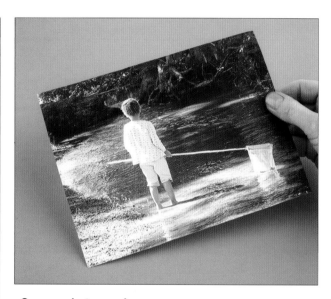

Source photograph

This photograph shows Yasmin paddling in a stream, with trees in the background. I am going to simplify the background to a beach scene, to tell a slightly different story. Remember that the photograph is just a starting point. We do not have to copy it.

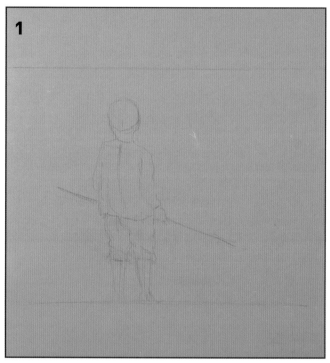

1 Following the thumbnail sketching instructions on page 114, use a red pastel pencil to start to sketch in the basic shapes of the figure. Add the horizon line using a ruler.

Colour palette

Unison blue violet 9, blue green 6, blue green 7, blue green 9, blue green 10, brown earth 14, grey 27, blue violet 3, blue violet 4, red 15 and add 42. The additional swatches are the pastel pencils and Conté crayons (see 'You will need' above).

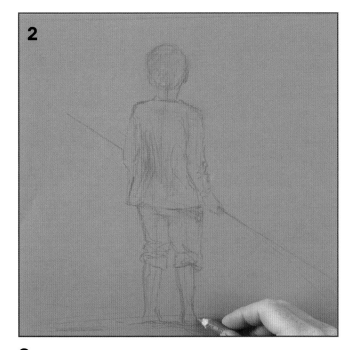

2 Take some time to refine the sketch of the figure. Look more closely, and add or strengthen the lines for particularly important parts – such as the creases in the fabric on her back. We're now looking at more than just the outline.

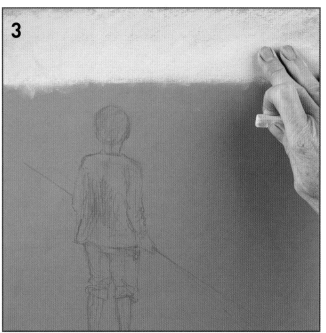

3 Using light blue and light blue-grey pastels, paint in a loose, simple sky above the figure. Soften it in with your fingers.

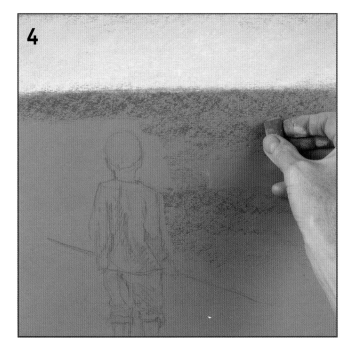

4 Using a dark turquoise pastel, begin to fill in the sea area. Use the side of the pastel to block in the large areas.

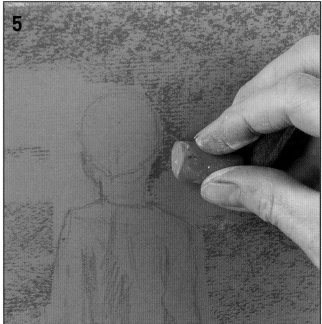

5 Change to using the edge for more careful working near the figure herself.

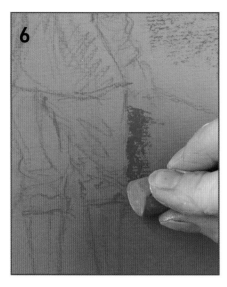

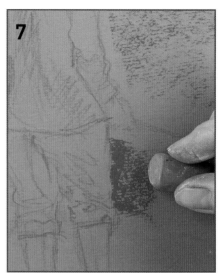

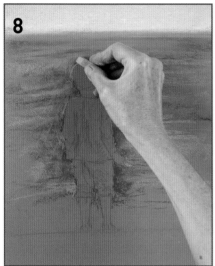

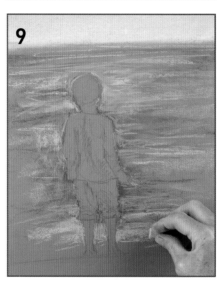

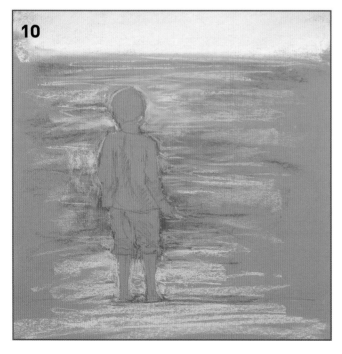

6 Still using the side of the pastel, but putting more pressure on the edge that you want to be clean – i.e. near the figure – will give a mark like this. I call this 'cutting in', and it is useful for getting a sharp edge without creating an outline.

7 On the softer side of the mark – i.e. the side where you were applying less pressure – you will find you can now overlay with the side of the pastel for a flawless join.

8 Introduce a mid turquoise pastel and continue building up the sea, using the new cutting-in technique to help you work around the figure. Avoid creating a complete outline around her.

9 Introduce some of the sky colours into the sea as highlights, and use light turquoise in the foreground.

10 Use the edge of the pastel to add some dark turquoise around the figure's feet, to suggest shadow. The light is coming from the left, so extend the shadow to the right. Use a sandy pastel to hint at the beach to finish the background. Note that the sea is developed more around the figure, and is left much looser as it gets further away. This helps to draw the focus to the figure. Take a break and wash your hands.

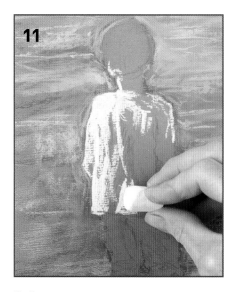

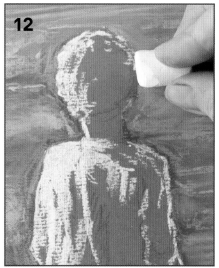

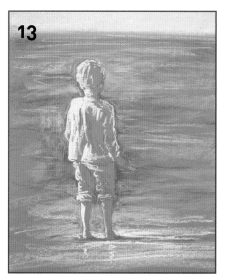

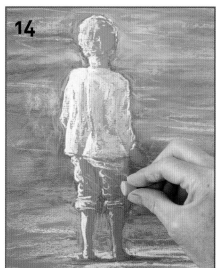

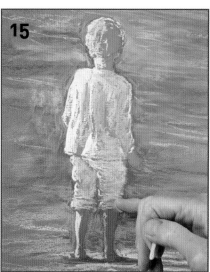

11 Using a cream pastel, start to put in the highlights on the figure. Look for the lightest lights on the left-hand side, and apply the colour with the edge of the pastel. Notice the importance of the contrast between the light figure and dark sea.

12 Use less pressure for the left-hand side. There are highlights here, but they are more subtle. Pay a lot of attention to the shapes the highlights make, as they are what describes the form.

13 Use the same cream to highlight the sea near the figure, and to suggest the reflection of her legs in the wet sand.

14 Looking for the shadows, start to add more colour to the figure. Use lilac and dark lilac on her top, and add a few hints on her trousers.

15 Use the darker of the sky blue pastels (light blue and light blue-grey) to develop some hints of colour on her trousers. Leave some of the surface showing through.

16 For very fine details, you can break a piece off your dark turquoise soft pastel so that you end up with a tiny shard (see inset). Use this to add deep shadows in the recessed areas.

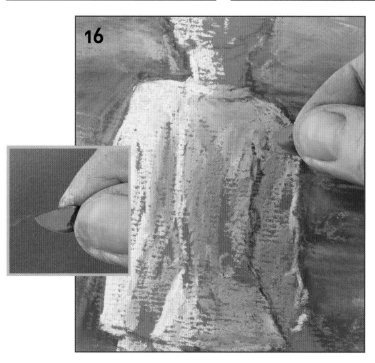

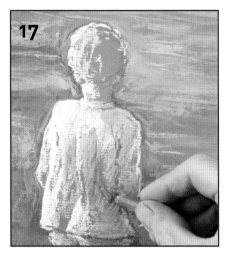

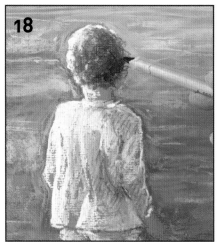

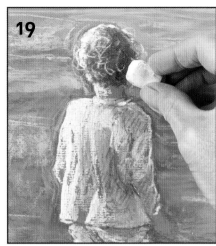

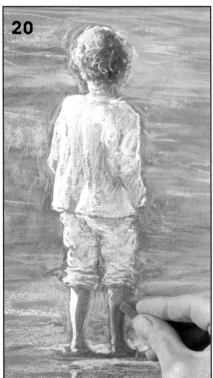

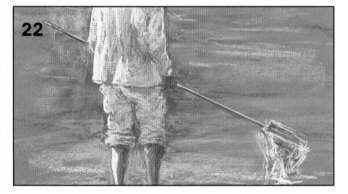

17 Use a dark blue pastel pencil to hatch shadows on the figure's top.

18 Using circular marks of a brown Conté crayon, add the figure's curly hair. Add shading with a dark brown pastel pencil and the dark blue pastel.

19 If necessary, reinstate the highlighting on her hair with swirly motions of the cream pastel.

20 Using a raw sienna Conté crayon, add some shading to the skin on the neck, legs and hand. Extend the colour down into the reflections in the sand with subtle swirling lines.

21 Being careful not to smudge the surface, use a ruler to help you draw the pole of the fishing net with a white pastel pencil.

22 Add the basic shape of the net with the white pastel pencil, then develop it with the cream and dark pink pastels and the red pastel pencil.

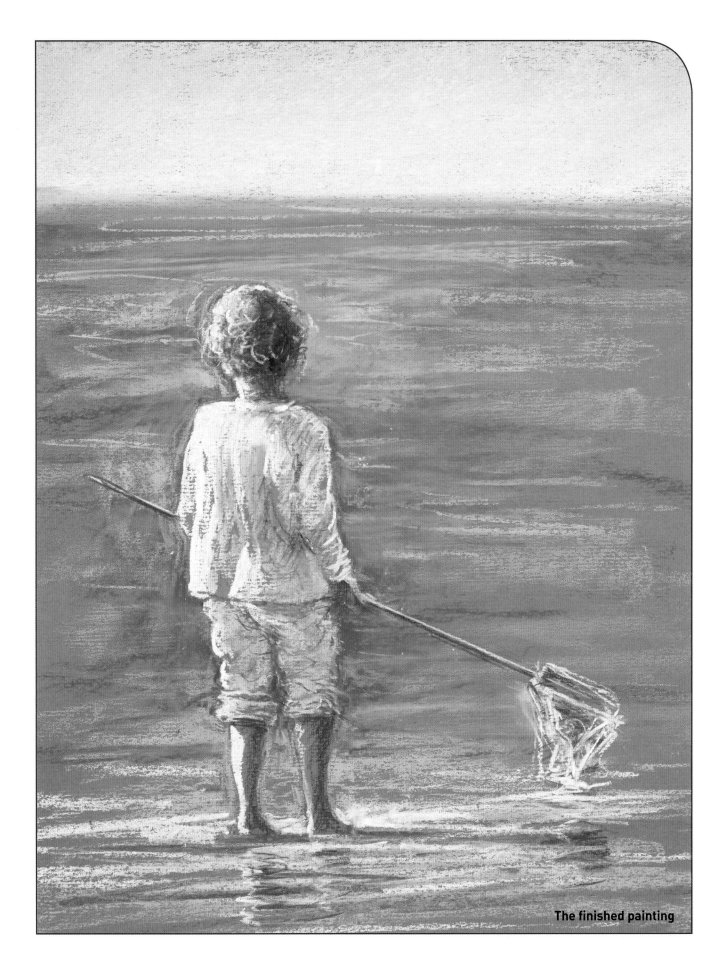

The finished painting

Portraits

Portraiture is a complex subject, and can easily be overwhelming for the beginner, but as pastels are such a perfect medium for capturing life, energy, and the textures of skin and hair, I couldn't resist including a few tips here!

A good portrait isn't just a well-executed drawing or painting, it also captures the essence and personality of the subject. This requires very careful observation. We nearly all have two eyes, a nose and a mouth, but we are all very slightly different.

Bone structure

When we recognize someone, we are looking not just at their features, but also at the shape of their whole head, i.e. their bone structure. We can identify someone by seeing the back of their head and just the curve of their cheek or brow.

The bone structure is closer to the surface in places, such as our brow bone and cheek bones, but in other places, such as around the jaw, is covered by fleshy areas. All of this is important as it will determine where we use light and shade to describe the form. See below for ways to simplify the proportions of the head, which will help with our paintings.

The human skull is narrow when seen from the front, but look how deep the profile is. Also notice how deep the eye sockets are, and how the jaw has a narrow curve.

Proportions of the head and face

A: The eyes sit halfway between the top of the head and the bottom of the chin.

B: The face is symmetrical, so if you draw a centre line down the middle, it is important to remember that as the head turns, that centre line will turn with it.

C: The head can be simplified to an egg shape with the sides sliced off.

From the hairline down to the bottom of the chin, the face can be divided vertically into three fairly equal sections:

D: Hair line to eyebrows, or brow

E: Brow to base of nose

F: Base of nose to bottom of chin.

The ears sit within the middle section (E), between the brow and the base of the nose.

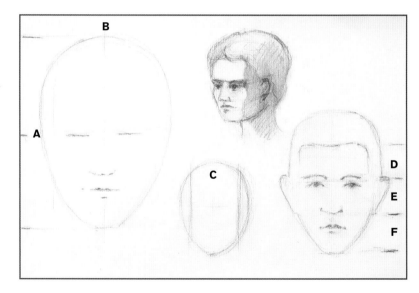

Colour mixing for portraits

Pastels are a fantastic medium for painting portraits, as the colours can be smudged gently or applied with speed to capture life and movement. The marks that you make will convey the feeling of the person you are portraying, and can be used to capture their character.

I like to combine the opaque quality of my lighter soft pastels with the brighter, intense colours of both pastels and Conté crayons, to create skin tones with depth. Just using the colours that we think of as traditional flesh tones can result in skin that looks flat.

Softening colours together works beautifully for capturing the soft smoothness of skin. By putting rich, intense colours on first, with soft pastels and Conté crayons, and then smudging opaque, lighter flesh tones over, you can create skin that has depth as well as smoothness and lustre.

Louis

This example uses hatching with Conté crayon and pastel pencils. Notice how the lines of hatching follow the contours of the lips.

It is good to practise combining subtle and intense colours before starting on an actual portrait.

Likeness, personality and mood

We can vary our application of pastels to capture different people and to create a mood. The three main ways are through changing our palette, our mark-making, and the tonal contrasts in our portraits. For drama I use darker, stronger colours, and bold marks. For a calm and peaceful composition, I lighten my palette and the pressure of my marks. The illustrations on these pages show a range of approaches.

As for personality, if you are lucky enough to have your model in front of you, then you can get to know them a bit. Let them chat to you; see how their face and pose change when they engage with you. If you are using a photograph, and you don't know the person, you can let your imagination fill in some of the gaps. Remember, art is more than just copying every detail of a photograph.

Titania

My lovely daughter Manuela dressed up for me to create this portrait of Shakespeare's feisty queen of the fairies. Although I photographed her outside in the garden, I used a dark surface and exaggerated the contrast of light and dark tones to create a feeling of stage lighting. Her pose conveys the haughty nature of Titania.

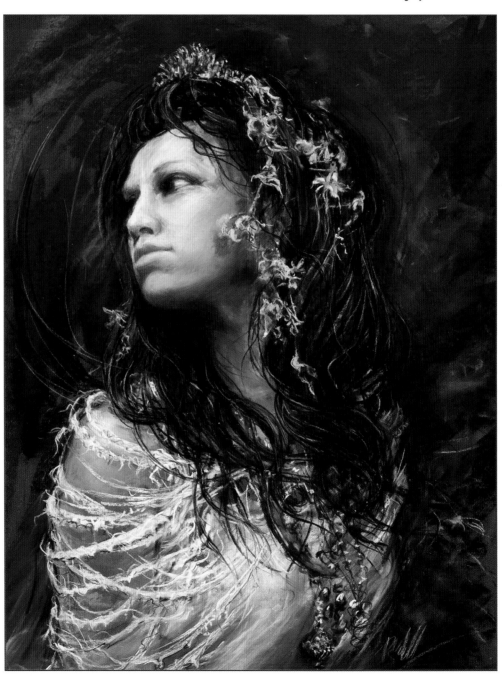

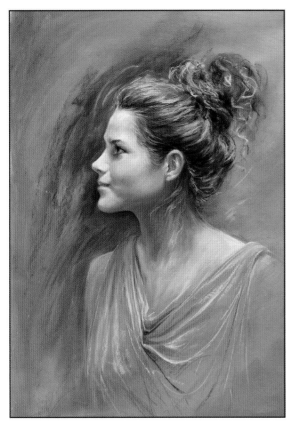

Polly

I chose this pose to set off Polly's beautiful profile. As this was my focus, I only hinted at her dress, and sketched her hair in loosely. Then to emphasize the focus, I used soft pastels, Conté crayons and pastel pencils to carefully draw in the details of her features, so as to draw the eye of the viewer to them. I kept my palette light to reflect Polly's personality.

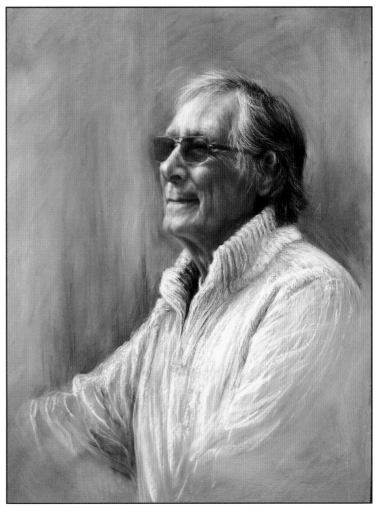

Malcolm

This gentle portrait captures the character of a gentle, kind, elderly man. I used the colours of Dartmoor in the background to reflect his environment, and built up layers of soft marks and textures to convey his peaceful appearance and the years of life and wisdom showing in his face.

Toby

There is no getting away from the fact that portraits are challenging; but they are also rewarding. This short demonstration uses the techniques you have learned through the book.

I like to use **Conté** crayons for the early stages, as they can be rubbed out easily with a pencil eraser. This means I can work freely without having to worry that the lines are exactly right. They also make a great base for using soft pastels as subsequent layers.

Many of the Unison pastels I use for portraits are light and opaque, so are great to apply over the rich saturated **Conté** crayon colours to produce depth. However, I also use saturated warm tones to give a warm glow to skin. The pastels I used are red earth 9, red 10, brown earth 6, brown earth 9, red earth 7, portrait 5, orange 6, grey 27, add 42 and light 5.

You will need:

WInsor paper: Terracotta
Pastels: Terracotta, pinky red, dark brown, warm mid brown, soft dusky pink, rich flesh tone, light flesh tone, cream and soft pale grey
Conté crayons: Black, dark brown, warm ochre and cream

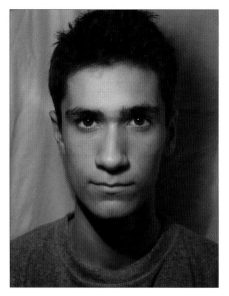

Source photograph
The reference photograph has been taken straight on to make the painting as simple as possible.

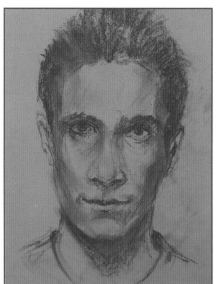

1 Sketch out the main dark areas with a dark brown Conté crayon, thinking of form and shadow as well as lines. Look for areas of light and shade but don't worry too much about exact detail at this stage. Aim to capture the general shape and form of the head.

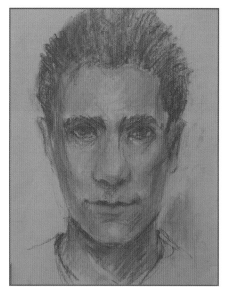

2 The next layer is again made with Conté crayon; this time a medium tone, warm ochre. In places I go over the darker brown. I only smudge slightly, as I am still working quickly to find the form.

3 Looking for the lights, I use a light cream Conté crayon. Notice how the nose, mouth and chin are a series of lights and darks. The mouth particularly is described with tone. The top lip is dark, light catches the lower lip, then there is a dark shadow under the lower lip, then light catches the fleshy area of the chin, then there is a deep dark under the chin. There is no line around the lips, they are simply part of a larger fleshy area. The form is more important than the individual features.

4 I then work into that scaffold, with soft pastels applied in layers. I start to smudge with my finger to capture the soft smoothness of skin. By smudging my opaque, lighter flesh tones over the darker, intense Conté crayons, I can create skin that has depth as well as smoothness and lustre. For more information about smudging techniques, look at page 32. I have used very dark Conté crayons to define the eyes, and shadows in the mouth.

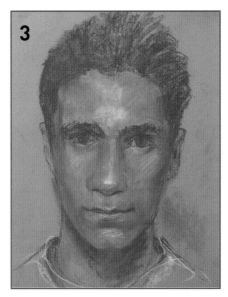

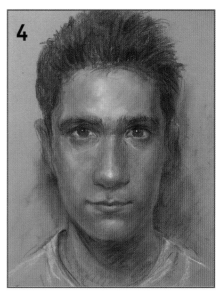

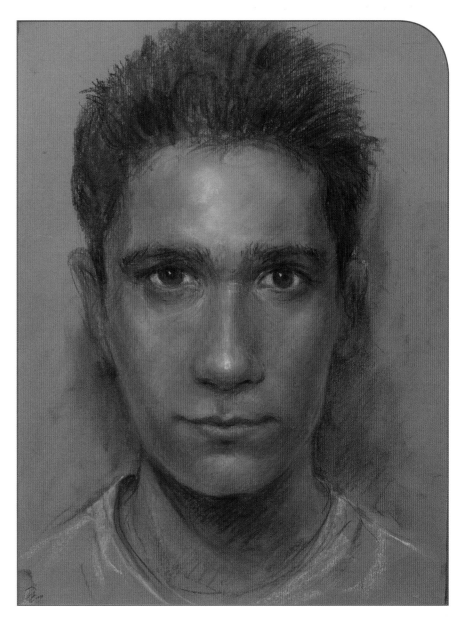

The finished portrait

Animals

Soft pastels are the perfect medium for drawing and painting animals. We can use many of the techniques that we looked at earlier in the book to create a variety of textures.

We are going to focus on animal heads here, so that we can concentrate on the textures. If you paint the whole animal in pastels, it will really help to work on a larger scale, in order to get detail in places.

As with human portraits, it really helps to have a little knowledge of the underlying structure. I try to simplify the structure into simple shapes, such as a diamond on a horse's face, which helps me to see the bone structure, particularly the prominent brow over the eyes. With a dog, I am looking for that 'step down' from the main part of the head to the muzzle, and the projection of the muzzle itself.

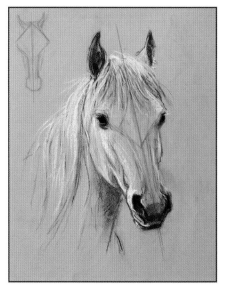

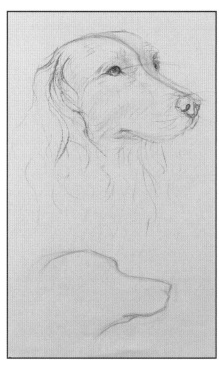

Centre line
When drawing animals, I always plot the centre line on their faces.

Building layers

On page 32 we looked at using the techniques in layers, and *Rosie* is a perfect example of this.

I smudged and softened in the black areas of her face before adding the cream wisps of mane over the top, with soft pastel shards and pastel pencils. I refreshed the surface with a plastic scraper before applying the lights, so that they would show up brightly against the dark layer.

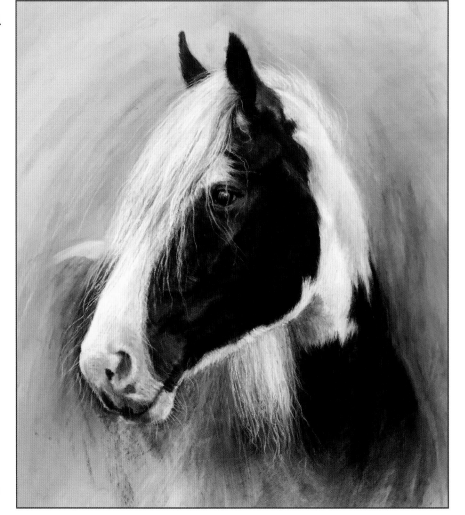

Rosie

◼ Fine work

If you are working on a small scale, or you want finer work on a larger painting, then pastel pencils can produce beautiful results. In this example, the finely bred Arabian horse has her short summer coat, so I needed to make fine marks to create the texture of short hairs.

I started by making a base of creamy grey soft pastel to work over, smudging it into the surface, then used pastel pencils to hatch fine lines. I used blues and purples to create shadow colours, and yellows and pinks to warm up lighter areas. This contrast in hue and temperature helped to create the feeling of sunlight falling across the horse's face.

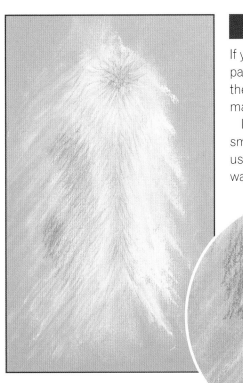

Muzzle detail

Esme

Notice how this technique of fine hatching is only used on the face. There is no need to go into detail all over the painting, and indeed, doing so can mean that movement and life are lost. I like to put my detail in the area that is the focal point. Remember: less is more.

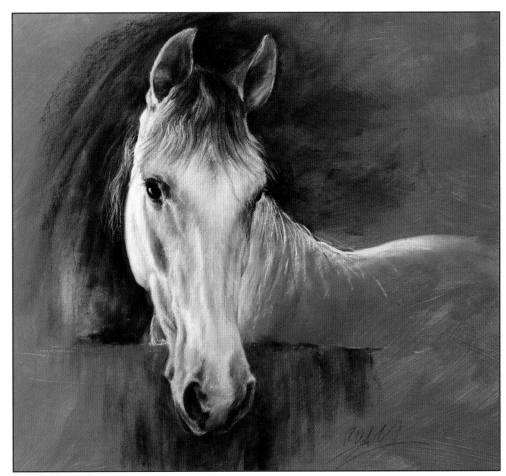

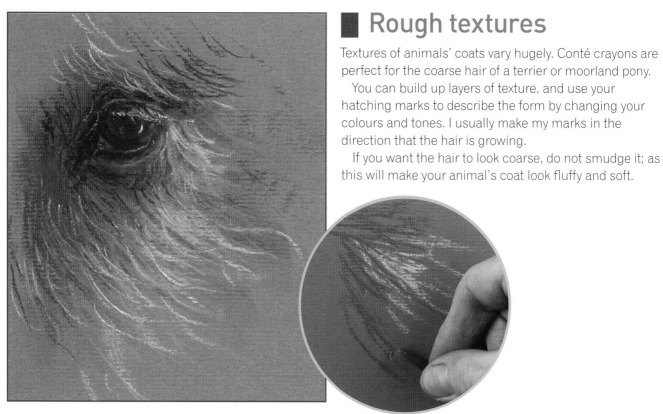

■ Rough textures

Textures of animals' coats vary hugely. Conté crayons are perfect for the coarse hair of a terrier or moorland pony.

You can build up layers of texture, and use your hatching marks to describe the form by changing your colours and tones. I usually make my marks in the direction that the hair is growing.

If you want the hair to look coarse, do not smudge it; as this will make your animal's coat look fluffy and soft.

Eye detail, Bramble

To hatch with Conté crayons to create coarse textures, I break the Conté crayons in half, and hold them in the middle. I make the hatching marks using the long edge of the Conté crayon rather than the end (see inset).

Bramble

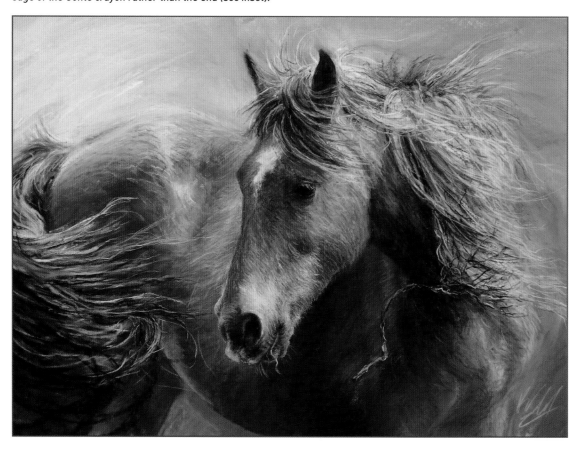

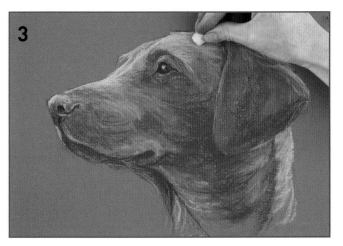

■ Building form through tone

Drawing and painting animals with pastels is not just about texture. We also need to describe the form for the animal to look real. Look back to the apple on pages 18–19, and you will see it was the light and shadow that made it look three-dimensional. We can follow the same process with our animal work, looking for the light, medium and dark tones.

To do this I pick out three main colours, one for each tone. I think of them as a mid-colour, a shadow colour and a highlight colour. Then I can develop my painting from this strong base.

1 Sketch out the initial shapes with a brown Conté crayon and some charcoal, just to position the dog – Ruby, a red fox labrador – on the paper. Using your dark soft pastel on its side, establish the areas of shadow.

2 Next, apply your midtone, turning and twisting the pastel to follow the contours of the dog's head. Redefine the eye, muzzle and edges of the ear so that you don't lose any important landmarks under layers of colour.

3 Apply the highlights with your light-toned pastel. As you draw and paint with your pastel, imagine that you are stroking the dog; feel the curves of the form of her head with your hand. It is easy to do this with pastels, as you hold them in your hand.

I developed the final piece using smaller shards of soft pastel to add details to her eyes and nose, and a black Conté crayon for the very dark details. Dogs' ears are very soft, so I smudged into those with my fingers, always thinking about the direction of the hair. I used a pastel pencil for the whiskers.

I only put in enough background to make her look three-dimensional, and used blue as it contrasts with her red colouring. I used the pastel on its side with vigorous strokes to create a feeling of movement; sketching around the area where the light is falling on her face. As the blue is darker in tone than the highlight colour, it makes the highlights jump out more.

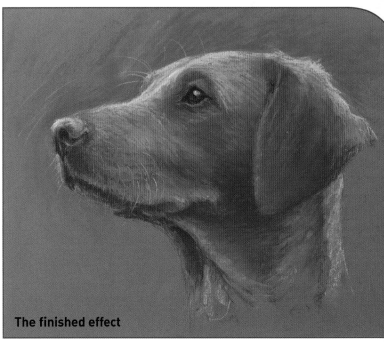

The finished effect

135

A dog's eye

In contrast to the softer textures of fur, eyes and noses are wet and shiny, The intensity and shiny quality of the eye is created by using strong contrasts of lights and darks, and by softening to create smoothness. You can add to the intensity of your drawing by showing the shadow cast by the prominent brow above.

This eye can be seen in the painting of the dog 'Flick' on page 49.

This eye can be seen in the painting of the dog 'Flick' on page 49.

1 Used a thin stick of charcoal to sketch the eye in simply, describing the basic shape and the pupil.

2 Put in the bright ochre and orange colours using soft pastels. Don't worry if you go over the pupil. Next, use the charcoal to lightly darken the line of skin of the lower eyelid. The soft grey of charcoal is similar to the colour of the animal's skin, so will be a great base to work over.

3 Using a black Conté crayon, deepen the dark shadows around the eye. Black Conté crayon is harder and sharper than charcoal, so gives a more defined and lasting mark. You might find it helpful to think of the eye as a marble set in a socket: the 'marble' will be shadowed below, as it is a sphere, but it will also have a shadow from the brow over the top.

4 For light glistening on the edges of the lower lid, I use a sharp white pastel pencil. This doesn't have enough pigment to give a really bright highlight over several layers of pastel, so for the shine in the eyeball itself, give a little flick of very light soft pastel which gives a bright mark.

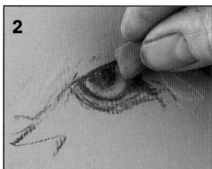

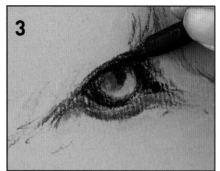

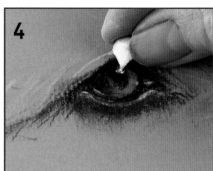

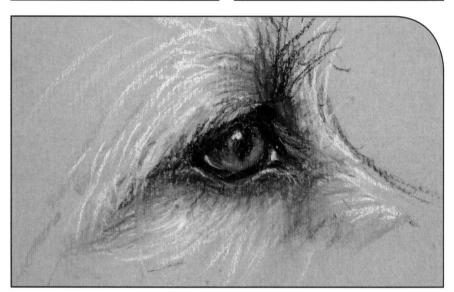

The finished effect

Marks have been added for the hair around the eye, using raw sienna Conté crayon and cream and raw sienna soft pastels. This sets the eye within soft, textured surroundings. I am always thinking about lights and darks as I do this, to keep a sense of the structure.

Tip

To get bright highlights, you need to use a soft pastel rather than pastel pencil, as the softer pastel has much stronger pigment in it. To be accurate with your mark, break a little shard off your larger pastel, either with your fingers or with the help of a craft knife. If you drop a pastel on the floor and it breaks, keep the shards for detail work.

◼ Shiny black fur

Black fur can seem daunting, but isn't too difficult if you work on a midtone surface such as the blue used here, which works really well as a base for black.

The trick with dark and shiny fur is to put in the darks, and then work the lights over them. As an example, let's look at a section of the soft, wavy hair on the ear of a black spaniel.

1 Sketch in a few lines with charcoal to indicate the flow of the lines.

2 Make linear marks using the long edge of the charcoal, twisting it to create shadows, getting a feel for the flow of the curves, and using a pencil eraser if you want to lighten any areas. Notice that as the lock of hair curves, it catches the light; this is where to rub back with the eraser. Smudge in the shadow areas with your fingers.

3 Using a light blue soft pastel, draw over lines of highlights, varying your pressure to create variations in the intensity and thickness of the line. You can soften in the ends of these lines with your finger, following the curves so they appear to flow in and out. Light blues work well as shine colours.

4 Use black Conté crayon to deepen the dark shadows, and some lighter blue or cream soft pastel on the shiny highlights, pressing harder to create brighter lights. Always think of the flow of the curves, and vary your pressure accordingly.

The finished effect

This sketch shows the ear in context. In the early stages of this piece, I am using charcoal to indicate my areas of shadow and form. Charcoal is a lovely medium to use for animal sketches. It is easy to rub out, and is similar in colour to the animal's skin, so forms a natural base for other colours. It also slightly fills in the texture of the surface or paper, so is useful if you want to create softer textures with other colours over it.

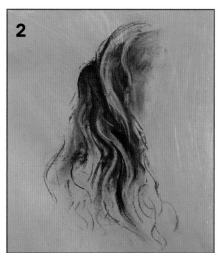

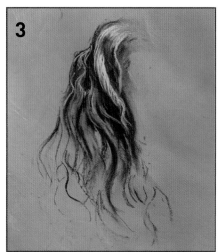

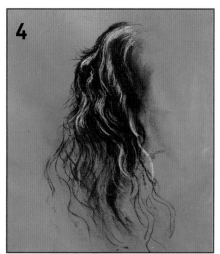

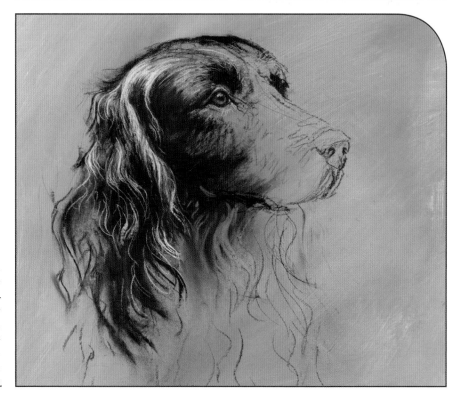

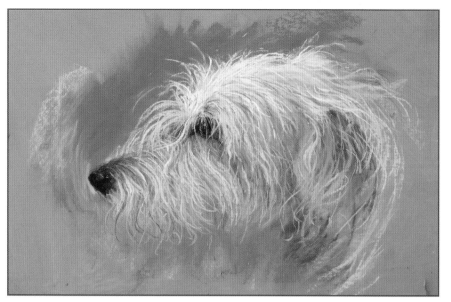

■ Background and setting

It's a good exercise to do the same sketch on different coloured grounds to compare how the pastels behave visually. It helps if you pick something simple to draw.

Although we have chosen our surface as a background colour (see pages 66–69), we usually need to add some additional background with pastel, in order to describe the form of our subject. Nothing exists in a vacuum: adding dark and light background areas will help to 'bring out' your subject so that it looks real and three-dimensional.

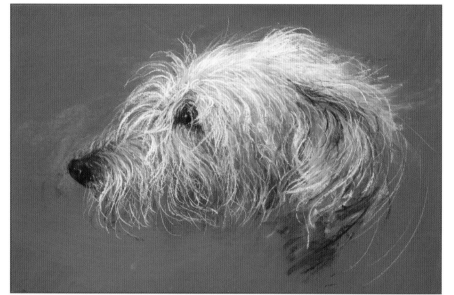

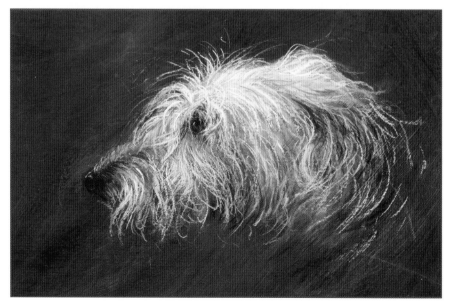

Top to bottom:

Pale neutral background

This is a sympathetic colour for drawing the light fur – i.e. the colour of background and subject are similar. I needed to put a darker toned background around it so that the light hairs showed up.

Dark neutral background

Another sympathetic colour and tone, as it is a similar colour to the dog's light fur, but also dark enough for the hairs around the edges to show up. This meant that I only needed to add a hint of a background colour.

Bright background

Here the tone of the bright blue means that the light fur of the dog jumps out at us, and little background is needed. However, I needed to put a layer of a neutral colour in places to work over with the lighter hair.

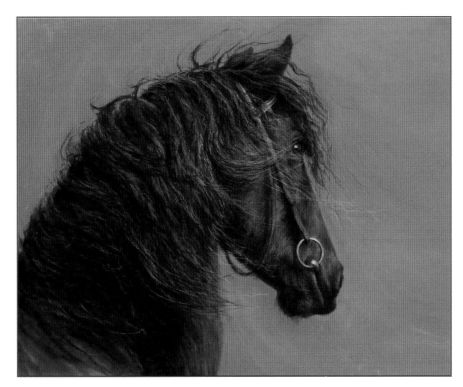

Watching the Storm

It can be fun, but also quite difficult to work on a really bright background. You have to be aware that some of the surface colour will show through your pastel work. With this black horse, I felt that a red surface colour would glow through the black, creating drama and warmth. Compare this with the dog on blue, opposite, where the blue forms part of the shadow colours.

Youth and Experience

I always try to simplify my backgrounds, only putting in what is important to telling the story. Here I wanted to emphasize the relationship of the horse and groom, so around them I concentrated on areas of simple light or dark. These were applied with muted sideways strokes of soft pastel softened by hand. The dust is soft cream pastel smudged over a darker background.

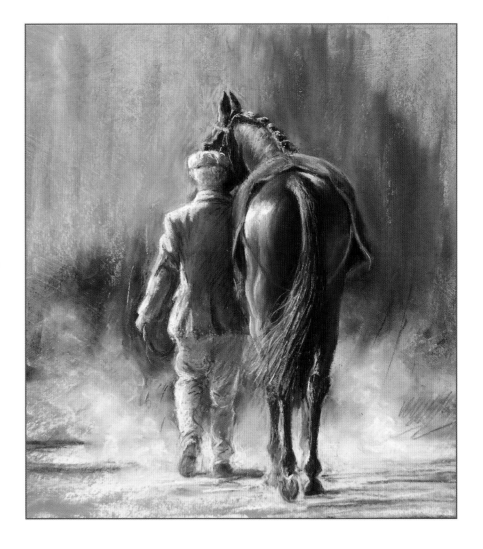

Composition

Composition is the division of the space that we are using for our drawing or painting; what we place where, and the choice of format (landscape, portrait or square?). It is your first chance to take control of your piece of art by making choices and planning. It can be the transition from you simply copying from a photograph, to creating a piece of art in its own right.
You can draw in the viewer and pull their eye around the whole painting so that everything is taken in before it finally settles on the main subject of the painting. There are a few ways that we can do this.

Dividing up the space

Many artists divide their picture space into an approximation of thirds. This is a simplification of the form of composition, used for thousands of years by Western civilizations in art and architecture, known as the Golden Ratio, Golden Mean or Golden Section. Basically, symmetry doesn't really work well in paintings and drawings, but if we put strong horizontals and verticals about a third (or two-fifths) of the way into our picture, it seems to create a sense of balance within the space.

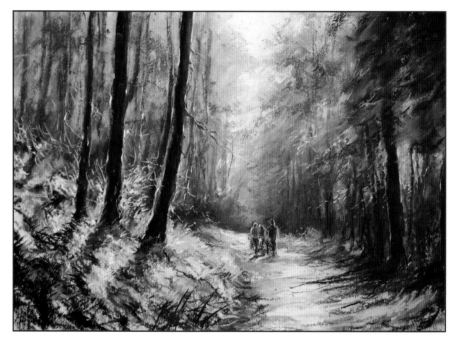

Dividing the space into thirds

In this composition the strongest tree trunk is a vertical line about a third of the way in from the left. The light catches the top of the path about a third of the way up from the bottom of the picture. The figures are also on this line.

The path is also adding to the composition, by leading us around the bend out of sight, which helps to tell the story of what is happening.

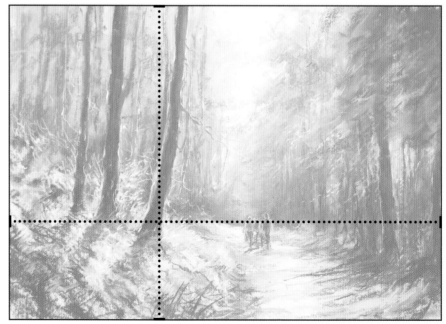

Using empty space

If a figure is facing or moving in a certain direction, it helps to have this space in front of them, or they can looked squashed in. *All Wrapped Up* has the figure about a third of the way in from the left, with lots of space for him to look into.

Red Sarong uses the 'less is more' approach. Using pastel pencils and soft pastels, I have put the most work, detail and tonal contrasts on the figure's upper body and head, but just hinted at her legs, feet, and the background around them, letting these areas fade into the empty space. As a compositional device, the pose of the figure creates a curve, which leads the eye up to her head.

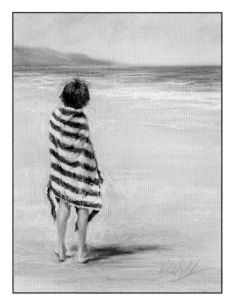

All Wrapped Up

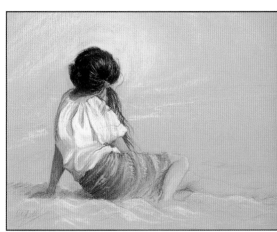

Red Sarong

Shapes and arrows

I like to use strong simple geometric shapes within my compositions, and use lines within the painting as arrows that guide the viewer around.

In *Marcus*, notice the triangular shape of the figure, but also how there are lines of flow leading along his outstretched arm, directing us from his head to his sculpture. There is also a strong line coming up through his leg towards his head, which curves over his head and leads us down to the sculpture again. This all gives the painting harmony and a sense of movement and purpose.

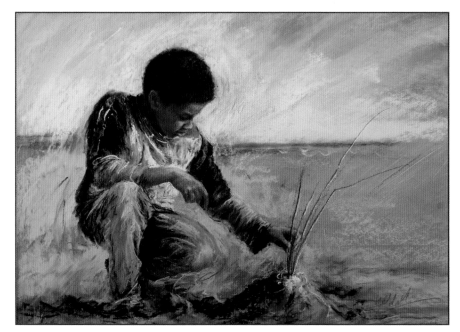

Marcus

People in groups

If you are drawing people in groups, look at the position and angle of their heads, as this usually tells us how they relate to each other. Are their heads close together? Are they looking at each other – or something else?

Think of the shape of the whole group before focusing on individual people. The negative space around and between them will help to sketch their positions.

Negative space

Thinking about the negative space around a group of figures can be a great help to understanding how they relate to each other.

Playing For Pennies

When you have a group of figures, the position of their heads will tell some of the story. Here they are close together, all focused on the game in deep concentration.

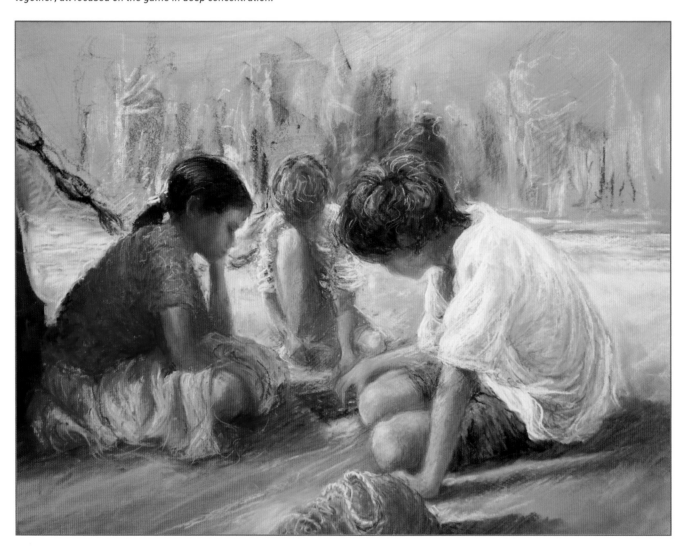

Composition with architecture

The main things to understand with architectural composition are that things get smaller as they recede into the distance; and horizontal lines, such as windows and roofs, converge at a vanishing point.

There may be more than one vanishing point, but they will all be on one horizontal line known as the eyeline. This is the level that you view the scene from, either if you are standing there yourself, or from where the photograph was taken.

On the example here you can see that the heads of the figures are all on this eyeline too, because I was standing up when I viewed the scenes, and the ground was level.

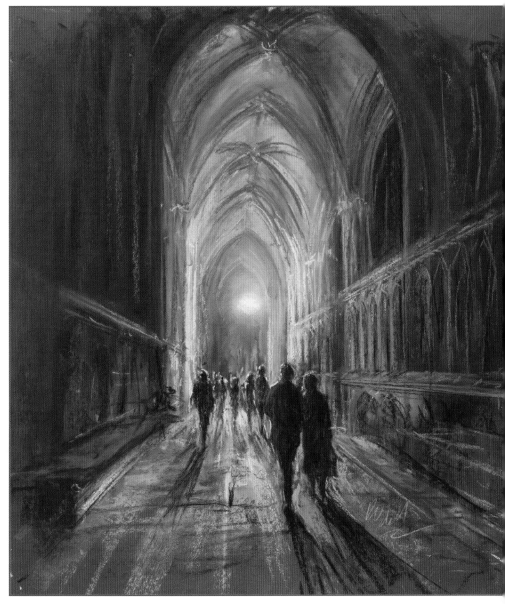

The eyeline is shown as a dotted line, while the vanishing point is a yellow circle. Note how the lines on the painting converge on the vanishing point.

Night Tour at the Cathedral

Notice on the insert how the horizontal lines are converging on one vanishing point. This is known as one-point perspective, and is the easiest form of perspective to get started with.

The heads of the figures are on the same level as this vanishing point. The position of the figures' feet changes as they get smaller in the distance.

Index